Basic Drawing

BASIC DRAWING

new ways to see and draw

by

RAPHAEL ELLENDER

DOUBLEDAY & COMPANY, INC.

GARDEN CITY, NEW YORK

TO ALL

WHO WOULD SEE MORE

ISBN: 0-385-04254-X
9 8 7 6 5

FOREWORD

Many of us envy the artist his ability to visualize quickly the basic forms of objects and to portray his conception in a picture. To develop such capacity is to give ourselves another mode of self-expression as well as a skill useful in many vocations.

In *Basic Drawing*, Raphael Ellender has developed a method for training the mind's eye to see not only the outline of an object but its form as a whole and the relationship of its parts. Each step in this process has been carefully worked out with many graphic illustrations and examples. The elementary principles of scientific perspective are also explained.

The Basic Drawing method has been successfully taught by Mr. Ellender in his classes in the Division of General Education of New York University. That so many students learn about these classes from former students testifies to the value of Mr. Ellender's method of instruction.

Taken in terms only of the skill involved, a knowledge of the principles of graphic visualization, as developed by the author, will be helpful to everyone. The roster of his students includes almost every field of professional and business activity—advertising, printing and publishing, medicine, architecture, fashion, cosmetics, design, engineering, teaching.

The serious student who plans a career in commercial or fine art, whether he is a beginner or an advanced student, can expect to find the concepts and procedures developed by Mr. Ellender of great value. They will result in more competently executed and esthetically pleasing drawings and paintings.

Carl Tjerandsen
 Dean
Division of Extension Services
University of California, Santa Cruz

CONTENTS

LIGHT AND SHADE

Adding the Third Dimension, Depth: the nature of light—scales of tones or values—the cube and the sphere in a scale of three values—translating colors to the black and white scale.

The Slanted Plane: the need for an extra value in the light—the sphere and the cube in a scale of four values—light, quarter & half-tone, dark.

The Patterns of the Darks: how changing the direction of the light from the source changes the shape of the dark areas.

Lighting for Effect: how the same subject changes in appearance and effect depending on the lighting.

Toning the Drawing: completing the picture, using four values of chalk or paint, on tinted paper—landscape and still life.

DRAWING THE FIGURE

Applying the Basic Drawing Method: the head, chest, and pelvis as basic shapes drawn within the Envelope—aids to drawing the basic shapes, upright figure, front and back views.

Bending and Turning: rotation of chest and pelvis—the torso (chest and pelvis) in perspective, seen as geometric bodies.

The Action Lines: how they show the tilt of chest and pelvis—the seven steps for quickly noting the action of the head and torso—standing figure and in motion, front and back.

Muscles of the Torso: their shapes, seen front, back, and in profile view—how they pass.

Rhythm Lines: connecting points and/or shapes with one another from side to side, top to bottom, to relate the parts of the figure to one another.

Arms and Hands: their basic shapes in action.

Legs and Feet: their basic shapes in action.

The Extremities in Motion: rotate in arcs, as do their joints—the arcs show perspective.

The Head and Features: as basic shapes, shown tilted and turned, in 35 positions, above, below, and upon eye level.

SCIENTIFIC PERSPECTIVE

Planes

Definition of Terms: picture plane, station point, ground plane, horizon or eye level, line of sight, point of sight, vanishing points.

One Point or Parallel Perspective: one plane.

Two Point Perspective: line of sight *within* the object on the vertical plane—eye level or horizon *within* the object on the horizontal plane, upright objects.

Two Point Perspective: eye level or horizon *outside* the objects, above and below them—how to find eye level—dividing a plane into equal parts—constructing other shapes on the surfaces of objects.

The Oblique or Slanted Plane: the Oblique V.P.—steps in drawing an object with slanted planes.

Foreshortening: its meaning and uses—how it is produced—how to compensate for the effect.

Three Point Perspective: when a third vanishing point is needed—the vanishing trace—objects tilted from vertical or upright position.

Circles

The Circle in Parallel Perspective: as part of a sphere it appears as an ellipse—the diameters parallel to horizon and line of sight—the longest diameter—the short diameter or axis—drawing the ellipse.

INTRODUCTION

In every field of study, the building blocks to achievement are the elementary principles of the subject to be mastered. As students acquire the knowledge and skill step by step, habits of thought and procedure are developed which later make for creative effort unhampered by lack of technical proficiency.

In this respect, then, the study of drawing should encompass more than the mere copying of outlines of an object, or group of objects, until perchance a reasonably correct graphic statement is finally produced. More important is learning to see, as against merely looking, and then developing orderly habits of procedure, as against a haphazard approach.

As to the first in importance, learning to see, my method helps develop mental perception by training the mind's eye to see first the whole shape as a mass, and *then* the relation of the parts to the whole. By working always down from the whole concept to the parts within, the eye is trained to see form in its entirety as to proportion and shape, and not just a sequence of lines.

Developing an orderly and logical approach, the second fundamental principle of learning, is presented as a step-by-step procedural method developed through years of teaching experience. As a system of visualization, it is not limited to certain subjects, but applies equally to all, no matter how complicated. As an orderly procedure my system is in sequence, permitting checking back for errors, should a drawing appear incorrect when completed.

In this respect, beginners usually tend to skip a step here and there. You are urged to restrain your impatience to complete the drawing, and instead, work systematically. Eventually your mind's eye and your photographic eye will be so well trained and co-ordinated that you will be able to make a correct statement without making all the preliminary steps. *A good rule to follow is always to draw first by eye, but never trust it when accuracy is important.*

As in all activities involving mental and physical coordination, the dexterity we know as skill is the result of constant practice, for which there is no substitute. Certainly this is true for drawing. If a work of esthetic value is the result of skill, observation, experience, and feeling, you must first learn to state what you *see,* then what you *know,* then what you *feel.*

As an aid to absorbing the concepts presented on the following pages, many of which may be entirely new to you, I recommend studying the illustrations and then reproducing the various steps in much larger scale, working from the photograph of the subject. By comparing your drawing with the illustrations, you will fix in your mind just what each step represents. Then try the same procedures from original subjects at hand.

The learning process for any new subject studied requires that each stage be mastered before moving to the next. This is particularly true when working from a book, where the student has before him a complete summary of the course. The temptation is to carry every early drawing to completion. Far better in the beginning is to concentrate on the elementary steps of visualization, working from many different subjects, gradually increasing their complexity. In due time, when the procedures of the first statement are fully understood and easily executed, you will be equipped to study the following steps one by one. In cultivating any new skill, the virtues of patience and fortitude pay off much better than mere enthusiasm and wishful thinking.

Raphael Ellender

SUPPLIES

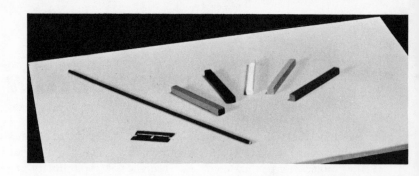

YOUR DRAWING MATERIALS ARE INEXPENSIVE

To learn Basic Drawing, you will need only simple equipment: a paper pad, chalks, measuring stick or rod, and a single-edge razor blade. At the start, you can use a smooth-surfaced newsprint pad, and later, layout paper or drawing paper. Always work as large as possible in the beginning. It is easy to draw small after working big, but very difficult to make larger drawings if you have always worked on a tiny scale. So when the subject permits, use a pad 18″ or 19″×24″. For smaller subjects, the 14″×17″ or 18″ size is adequate if you work as large as possible on the page.

For chalks, use any semihard pastel sticks with square ends, such as Nu-Pastel, in the following colors: raw sienna, either Tuscan or light red, burnt umber, black, and white. Do not use the whole length of chalk when drawing, but rather a small piece of it, about one third. Hold the chalk between the fingers of one hand at the place you wish to break it off, and snap off the remainder with the other hand in order to keep the ends square. You use chalks, instead of pen or pencil, to compel you to draw lightly and so develop a sensitive line.

When drawing, use only the corner of the chalk, never the flat end. As the corners wear down, renew them by slicing the ends off square with a razor blade. If you prefer, a sandpaper block may be used.

For measuring, use a length of ⅛″ dowelling, about 14″ or 16″ long, or any thin brush. Do not use a ruler, since you do not measure mechanically in inches but only for proportion. Notice that your equipment does not include an eraser.

SHARPENING THE CHALK

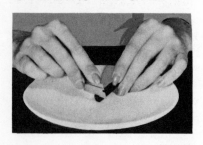

WHY WE DO NOT USE AN ERASER

An eraser is not included in your equipment because your objective is to train your eye and hand to work together accurately—on orders from your *mind's eye*. Mistakes are part of the learning process. By leaving all your lines on the paper, you are constantly aware of mistakes in vision or coordination. If you erase lines as you proceed, you will only be deceived into thinking that you see better than you really do. It takes many, many hours of practice and training before you can make a successful single-stroke outline drawing without preliminary under-sketching. Remember that the untrained eye is

very deceptive. Even the thoroughly trained eye cannot be trusted when extreme accuracy is required. An experienced artist always draws by eye, but never really trusts it. That is why you must learn how to measure your subject to check what you think you see. *By not using the eraser as a crutch, you will learn to think before you draw, rather than afterward.*

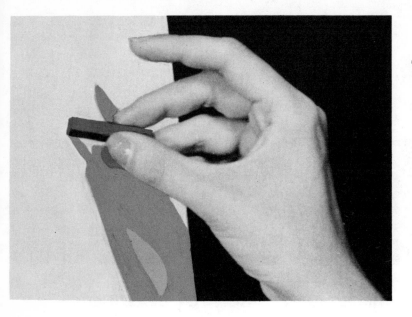

THE CORRECT WAY TO HOLD THE CHALK

The correct way to hold the chalk, pen, or brush is between the thumb and *middle* finger. Since this manner of holding the implement is new to most, accustom yourself to it by drawing for a while with the index finger held completely off it. Do not grip the chalk tightly. In a very short time you will find how much easier it is to draw with a light touch and a free swing. Your fingers and whole arm are relaxed and move as a whole. Holding your chalk between thumb and index finger will tense them and cramp movement.

WRONG

To steady your hand, try not to rest the whole palm or wrist on the pad, but rather only the tip of the little finger and the outside of the wrist bone, using them as pivots, so that the chalk, or pen, or brush is in a straight line with the forearm. *You will acquire improved legibility and ease in your handwriting if you hold your pen in the correct way.*

For a stronger line, bear down with the whole arm, rather than just the fingers. If your lines are becoming too thick or heavy unintentionally, it is because: 1. the corners of your chalk are becoming rounded and should be squared off, or 2. you are tired and too tense, or 3. you are not exactly clear in your mind about what you wish to do, and hope that, by pushing down harder, your fingers will put the chalk into the right place. *Your fingers do not make decisions. Your mind does.*

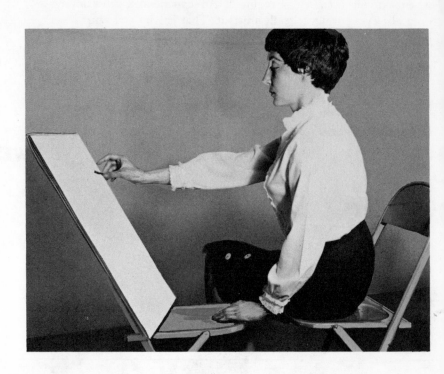

THE PROPER POSITION FOR DRAWING

WRONG

Drawing is much easier and more fun when in a relaxed position. To avoid muscle tension, the pad should be at arm's length and as nearly upright as possible. Best, of course, is on an upright easel, but a chair serves almost as well. Whether chair or easel, place it at an angle to your subject and never in a straight line with it. By doing this, you will be drawing from memory rather than copying like a machine, because you will be compelled to turn your head to see the pad.

Tie a string around the seat of the chair to keep the pad from slipping. An extra cardboard behind it helps to keep it flat. Sit up straight and draw with your whole arm in a free-swinging motion. As in golf or tennis, a smooth rhythmic swing with follow-through gives better control and a light touch. Start your swing from in front of the line and follow through in the same direction beyond its end. It is better to draw two or three whole lines to arrive at the correct one than only one line that is a series of jerky, ragged small pieces. Extra lines on your drawing will not harm it, but rather give it movement and vitality.

The reasons we do not draw bent over a flat pad are obvious in the illustration. The body is cramped and tense, the arm has no freedom, and vision is confined and distorted. If an extra chair is not available, tilt the pad against table or desk, resting its bottom on the knees, with the back straight. Sit far enough back from it so that your whole arm can swing freely with each stroke.

FIRST STEPS

HOW TO DRAW A STRAIGHT LINE

"Look where you're going
. . . not where you've been,"

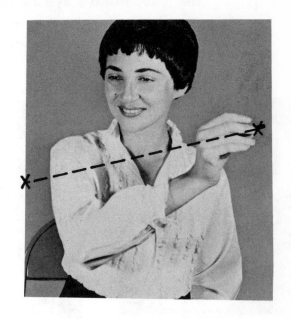

is the secret. Place two marks on your paper, any distance apart. Put your chalk on one, and focus your eyes on the other. Then let your hand join them. It will move in a straight line just as in reaching for a ball. Try this several times—up and down, across, at an angle, from left to right, and right to left. Now you can no longer say you need a ruler to draw a straight line. To develop a free swing, start your stroke in front of the mark, before touching chalk to paper. Follow through with your whole arm after reaching the second, or last, mark.

Curved lines are drawn in the same way. Curves are of several types, called "flat, or slow," "round, or fast," and "reverse, or S." To draw a curve, space three marks on the paper, not in line. Now, "Look where you're going . . ." and your arm and hand will swing freely to join them in a smooth curve, whether flat or round. Using four marks, do the same for a reverse, or S, curve.

Now that you have practiced using marks as guides, you can do without them by visualizing the direction and shape of any curve in your mind's eye, then drawing it with a single stroke. Remember to hold the chalk lightly for a light touch, and to use only the corner of the chalk for a clean sharp line.

HOW NOT TO DRAW

If you have had trouble drawing straight lines, or smooth flowing curves, it was probably because you tried to sneak up on the point you wished to reach, using a series of short jerky movements of your hand or fingers. Drawing this way keeps you from working freely and causes many errors because you do not see the line as a whole. To get a smooth, even line you must know where your line is to go, and with one quick stroke cover the whole distance, swinging the whole arm from the shoulder.

Accuracy comes through trained vision and practice. Better to be decisive, even though wrong, than timid and weak. Surplus lines give movement and life to the drawing, rather than harming it, if they are drawn freely. So have courage and draw confidently, even though you do not feel that way at the start. You need only throw aside a poor start and begin again.

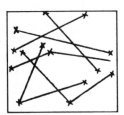 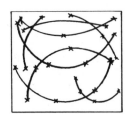

SEEING THE BIG THINGS FIRST

Use your mind's eye to see the whole shape

by joining the outermost points and outlines

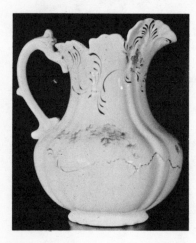

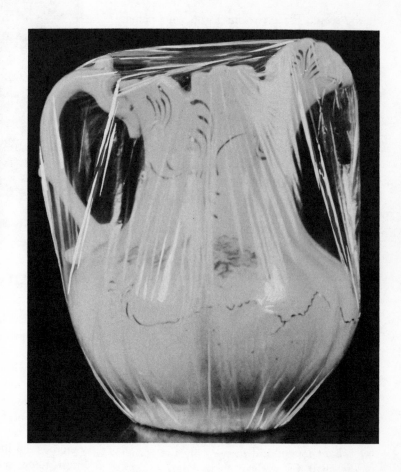

Learn to see things as a whole before finding the parts.

An easy way to understand the whole shape of an object is to imagine how it would look when wrapped in cellophane or plastic, as you see the Dresden pitcher illustrated above. Notice that the wrapping connects the outermost points with one another, as well as with the form of the object where it conforms to it. This total enclosure of the object is called "The Envelope" because every part of the object is contained within it. To begin with, you will study several single objects enclosed in Envelopes, and later learn to enclose any subject, however complicated, in an Envelope.

NEW WAYS TO SEE AND DRAW

to make **"THE ENVELOPE."**

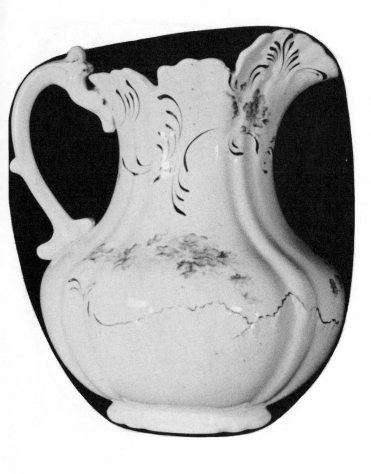

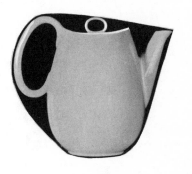

Sometimes an object is so uneven in outline, or has so much space between the extreme points and the form of the object, that it is difficult to visualize a plastic wrapping. In such a case, try to imagine the spaces between the outermost points and the form of the object to be filled in solidly, as with clay. And once again, you have created in your mind's eye the whole shape of the Envelope. Seen this way, the intricate outline of the object has been reduced to a simple flat pattern of the whole shape, into which the parts are later fitted.

**some other
familiar objects
and their
"ENVELOPES"**

DRAWING "THE ENVELOPE"

After visualizing the shape of the Envelope

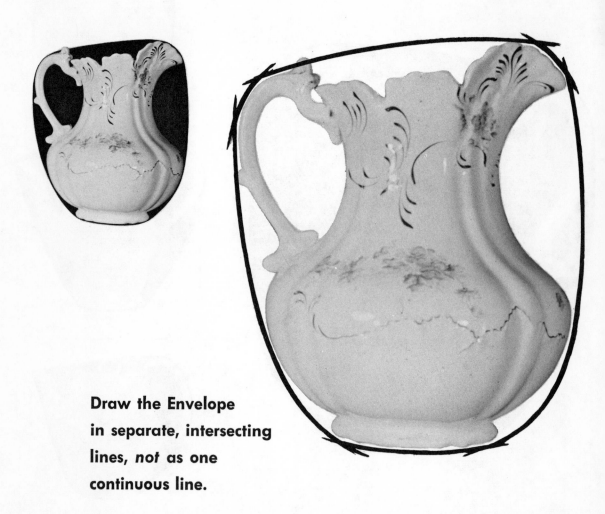

Draw the Envelope in separate, intersecting lines, *not* as one continuous line.

After studying the object and fixing the shape of the Envelope in your mind's eye, draw it freely as the first step in a representation of the object. Remember that the Envelope does not follow all the outlines of the object but only the outermost portions of the forms. Do not draw it as a continuous line but as a series of intersecting lines. The intersections serve you later as points of reference for finding the parts within the whole. Start with the easiest line you see, using the lightest colored chalk, drawing lightly. Here the lines are quite dark for demonstration purposes.

draw its shape as it appears to you.

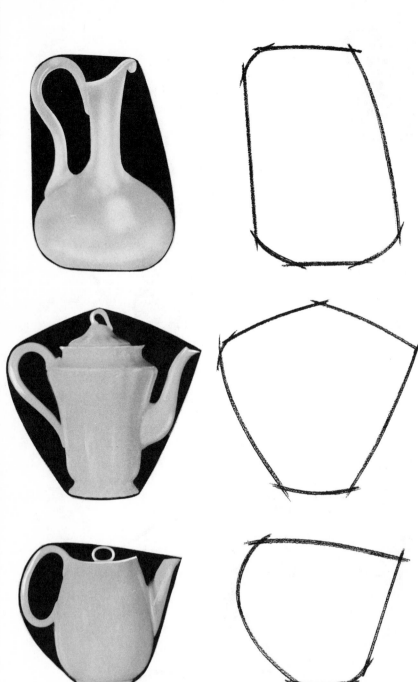

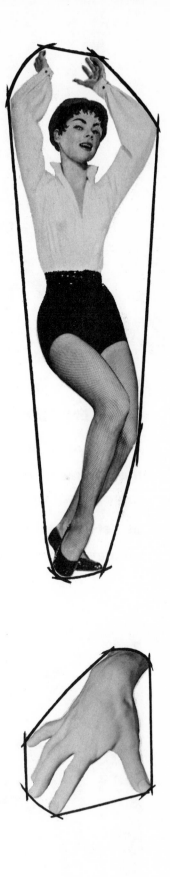

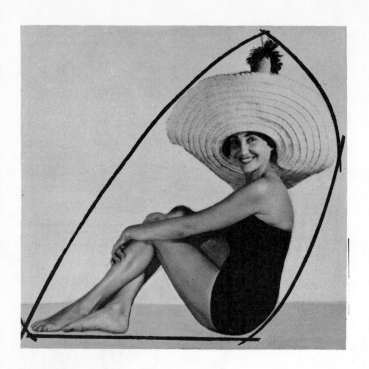

MORE ENVELOPES

Their shapes are found by connecting
the outermost points and shapes
with curved or straight lines,
as determined by the subject,
whatever its nature.

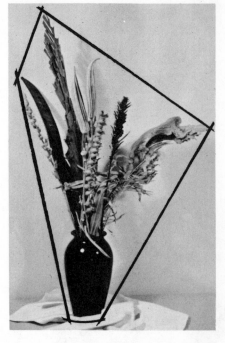

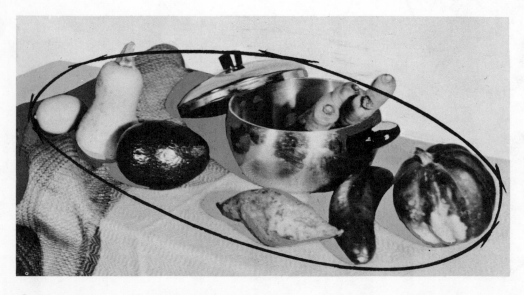

STUDY THE SUBJECT
BEFORE YOU DRAW

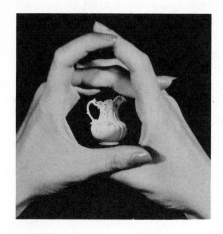
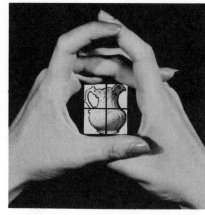

Drawing the Envelope showing proportions.

A few minutes spent studying the subject before starting to draw will save time making corrections later. This study involves: first, an understanding of the relation of width to height of the object; second, the shape of the envelope in its simplest terms; third, the location of some point or portion of the object at or near the center of the whole.

AIDS TO STUDY OF THE SUBJECT

One way is to look at it through a rolled-up tube of paper. In this way you isolate it from its surroundings, thus sharpening its outlines. However, since the tube relates the object to a circle, it is not as useful as a second method, which is to relate the object to a rectangle. To do this (if you do not have a photographer's adjustable cropping rectangle) use the sides of the palms and the thumbs and middle fingers of your hands, as illustrated. By adjusting the size of the rectangle, thus roughly formed, and bringing it closer to or farther from your eyes, you can place it so that it touches all four sides of the object. You now can compare the direction of the lines forming the envelope with our only two constants, the vertical and the horizontal lines making up the rectangle. The rectangle itself has already given you an approximate

relation of height to width. Fix these in your mind as a visual memory.

LOCATING THE CENTER OF THE OBJECT

Within your mental rectangle enclosing the subject, imagine center cross hairs within it, as on the ground glass of a camera. Now you can visualize the envelope shape even more accurately by comparing it in relation to the center points on the sides of the rectangle as well as to the center of the whole.

MAKING THE FIRST STATEMENT

Having fixed the envelope shape and proportion in your mind, make your drawing quickly, not as one continuous line but as a series of intersecting curves and/or straight lines, using your lightest colored chalk. After a little practice, this first statement will be almost always quite correct. However, since your eyes and hands are not trained, you must always check your envelope for proportion. Obviously, *if the relation of height to width of the whole shape or envelope is not correct, then everything inside it will be wrong.* To check out this first drawing of the envelope and correct it if necessary, you must learn to measure.

FINDING THE RELATION OF HEIGHT TO WIDTH

The illustration below shows how to use a rod to measure an object. Holding the arm fully extended, with the rod upright in a vertical position, line up the top of the rod with the top of the object, and adjust the position of the fingers until they mark the bottom of the object. This length on the rod corresponds to the height of the object as seen from your station point.

Without shifting the fingers, the rod is turned to a horizontal or level position, arm still fully extended. With the free hand, mark off the width of the object at its widest points on the rod. If the width is the longer dimension, reverse the order. The relation between the two measurements, width to height, is a proportion of one to the other.

Our measuring is not in inches, but in proportions. Now we check our drawing of the envelope to see if it is correct. If not, we redraw it to the proportions as we now know it should be. Obviously, if the envelope is not true to the object, width to height, the parts within it will be distorted.

If your rod is not long enough, then measure by halves from the center. Remember to hold it between two fingers only, shown in the photos, to avoid tilting from a true vertical, or slanting away from parallel to the eyes when horizontal. Otherwise your measurement will not be accurate or remain constant. For the same reasons, *the arm must always be held fully extended when you measure.*

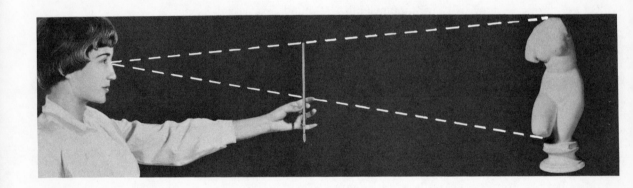

WHEN WE MEASURE, WE FIND A PROPORTION

Always draw the envelope first, after studying the subject, *then measure.* After establishing the relationship between the longer and the shorter dimensions of the object, as a proportion, you now must translate this in terms of your drawing.

Suppose your measurements are equal, one to the other. Then you have a proportion of one to one, which makes a square. Obviously, if your envelope does not correspond, it must be corrected. In another simple example, suppose one dimension is twice the size of the other, or, if you prefer, one is half the size of

the other. Now you have a proportion of two to one. Now, if on your drawing of the envelope, the shorter dimension is either more or less than half of the longer side, then it must be corrected. In this way, we arrive at proportions, such as four to three, three to one, five to four, and so on, and check our envelope accordingly. Divide the longest dimension on the envelope into the number of units required, five, four, three, etc., and measure the number of them needed to make an accurate proportion for the shorter side of the envelope.

HOW TO MEASURE

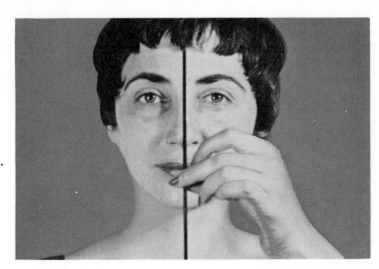

Sight the longest side first, whether height or width, with arm fully extended. In the photo, the hand is closer to the head to avoid the distortion of the camera lens.

WRONG WAYS TO HOLD THE ROD Never measure with the rod held in any position other than truly vertical or horizontal. Never grip it in your fist.

With the free hand mark off the second dimension, as compared to the first or longer one, also with arm fully extended. The relation between the two is a proportion.

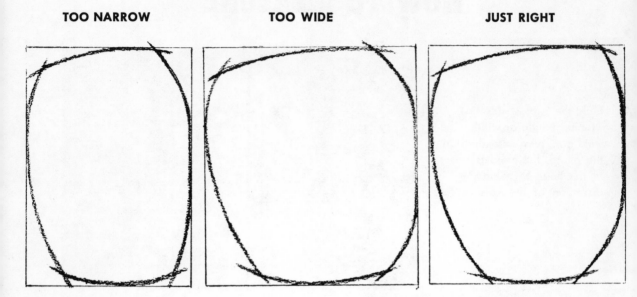

TOO NARROW **TOO WIDE** **JUST RIGHT**

PROPORTION:

The Use of the Rectangle

**Enclose the Envelope
in a rectangle to help you measure
its proportions accurately.**

In the examples so far studied and perhaps also in any subjects of your own, you will have observed that in most cases the envelope containing the whole subject is not symmetrical. That is to say, the sides are not equivalent to one another. When this is so, the widest points are not directly opposite one another on a level line, or the highest and lowest points are not on a vertical line. To measure them means measuring at an angle, which we never do, because angles other than a right angle are not constants. Therefore, to simplify your measuring of the drawing, create a series of right angles by enclosing the envelope in a rectangle.

To do this, draw horizontal lines at top and bottom, and vertical lines at the sides, each touching the extreme outermost points of the envelope. Now, since the sides are parallel to each other, distances between them, at any point, are equal when measured vertically or horizontally. The straight sides of the rectangle are also useful for dividing into units that establish proportions of the sides to one another.

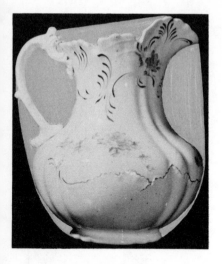
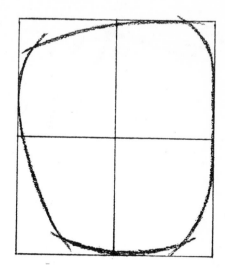

FINDING THE CENTER OF THE RECTANGLE

After measuring the rectangle, compare its proportions to the proportions of the object. If not correct, then redraw or correct the envelope. If the whole shape, or envelope, is not reasonably accurate as to the relation of width to height, proceeding further within it, without correction, will only compound the felony. Once the envelope is correct, find the centers of the sides of the rectangle, and connect them with a vertical and a horizontal line. Their point of intersection is the center of the rectangle. Find the center points on the sides by first making a mark by eye, at approximate midpoint, then checking it with your rod to make sure you have divided each line exactly in half. Always find your midpoints first by eye, to help train for accuracy.

THE CENTER LINES AND POINTS HAVE MANY USES

It is because we all have a natural sense of the vertical and horizontal that we can hang a picture correctly, and, consequently, can tell when two opposite points are upright or level. By drawing center lines within the rectangle, we can compare opposite points on the envelope in relation to either a vertical or horizontal to determine how much they depart from either. By holding your rod up to the object, you can compare the angle a slanted line takes with your mental visualization of the center lines.

The envelope gives us our whole shape. The center lines and center point give us a reference within the envelope for the shapes within it, as to left or right of center, above or below center. Also the center lines divide our whole shape into quarters, or four smaller rectangles within which we can work on smaller units of the whole, in the same way.

THE BIGGEST SHAPE within the Envelope

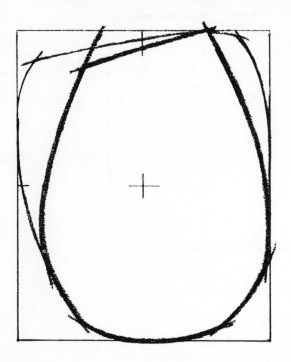 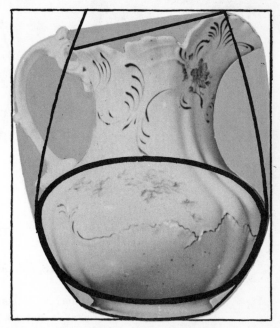

SEEING THE BIG THINGS FIRST

You are still learning to see an object as a whole shape made up of several parts, rather than in the more familiar way, which is just the reverse; that is, as an outline of the parts to make up the whole. Your next step, therefore, is to find the biggest shape within the envelope.

Our single objects for demonstration and study are composed of a main body, plus attached units such as spouts and handles. Understood in this way, the biggest shape in the envelope of the Dresden is not the bowl but the whole body of the pitcher. The body of the teapot is easy to recognize; the decanter more difficult. Always remember that the biggest shape is the whole main body; that is, the largest bulk or mass within the envelope, and that *same portion of this biggest shape is part of the envelope.* This bulk or mass, of course, is a changing shape

depending on the nature of the object. Just as with the envelope, you must visualize its nature and shape in your mind's eye, and not rely only on what you see with your camera eye.

After identifying the biggest shape in the envelope, study its location in relation to the center lines within the rectangle by mentally visualizing them on the object. Notice the position of the body of the pitcher in the illustration above compared to the center of the rectangle, which contains the whole of the object. Also notice that all of the biggest shape is within the envelope.

Since all the steps so far are preliminary to your final drawing, use your lightest colored chalk, which will disappear later under the darker colors. Remember to draw lightly, using only the corner of the chalk for a thin line.

and the NEXT BIGGEST SHAPE

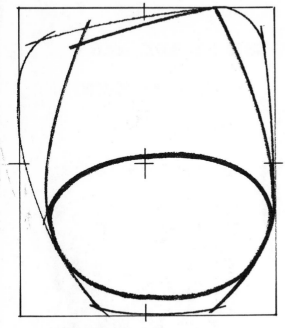

Continuing now to fit the parts within the whole, look for the next biggest shape within the envelope. In the Dresden pitcher and the decanter, it is the bowl of each. In the teapot, it is the pot itself minus the cover and foot. On a single object, the Next Biggest Shape is always a part of the Biggest Shape.

When drawing a symmetrical object, it is helpful to find the vertical line through the center of the biggest shape or main body, in the event that it is not the same as the center of the whole envelope. Then both sides can more easily be drawn alike.

You have now completed the most important steps in the Basic Drawing method. *No matter what the subject, these steps must be done first.*

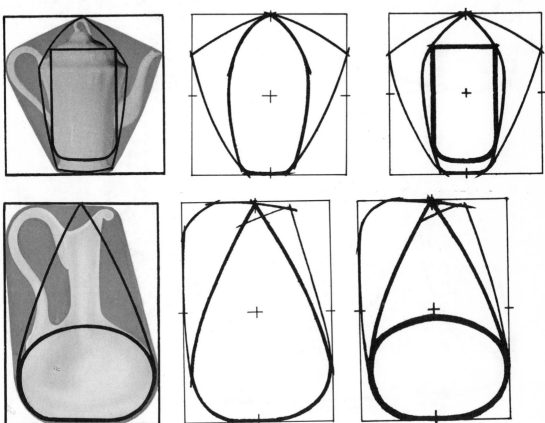

THE BIGGEST SHAPE and NEXT BIGGEST SHAPE
in the Envelope

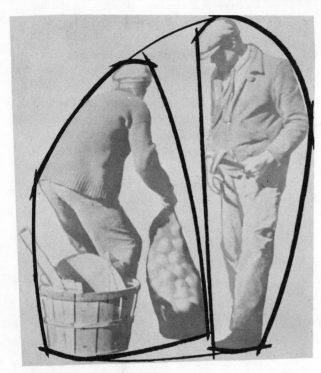

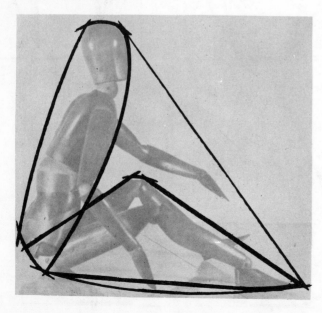

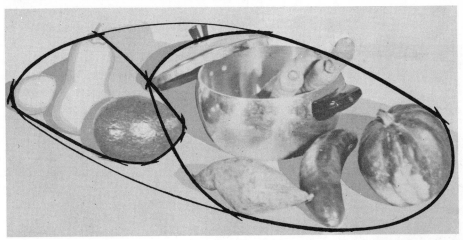

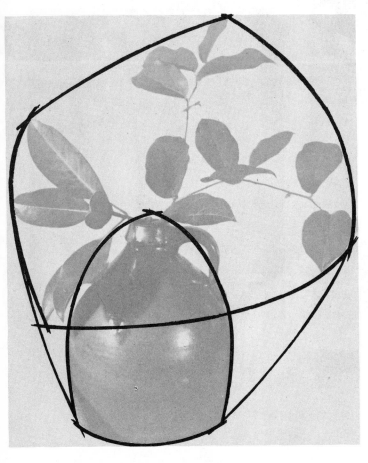

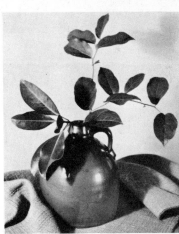

Your X-ray Eye, through projection, sees into the object,

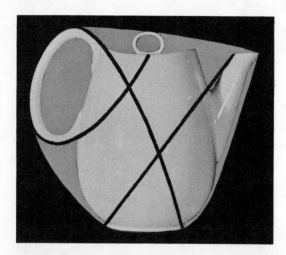

Now that you have learned to see your subject as a whole before finding its parts, you are ready to expand your mental vision still further by learning to see the rhythms within the shapes. Since these rhythms are not actually visible in the way they are shown in the illustrations, we will use the term "X-ray Eye" to explain what we are trying to do. The X-ray reveals solid forms underneath the surface of objects as they exist, even though invisible to us. You will learn to see in your mind's eye the projection of a line or shape that is part of the outline of an object, as it crosses through it to join a related line or shape opposite, *as though it actually existed underneath the surface.* The diagrams on these pages illustrate how we find the rhythms inside our four study subjects—

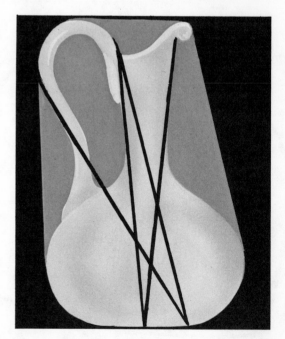

RHYTHM DRAWING

revealing the connecting rhythms within the boundaries.

shown here as lines superimposed on the photograph.

As you practice looking for these rhythm lines within familiar objects in your home, you will find that well-designed objects prove the reasons for their beauty by the connecting rhythms within them. Their boundaries are related to one another within the object in smooth-flowing, connecting rhythms.

Learning to see with your X-ray eye gives you one more way to see the whole shape in your mind's eye while you focus on any one part. You are learning to see across, from side to side, and up and down, from top to bottom, and thus compare locations of points and shapes to the whole all of the time you are drawing. Since you can draw only one part at a time, the only way to be sure your lines are placed properly is by constantly comparing their position in your mind's eye with points or shapes opposite.

To learn to see in this way, study your subject carefully, and try to find the connecting rhythms. Join any parts of the outline of a shape that connect rhythmically with parts opposite, even though such a connecting line does not actually exist on the object. You must keep your eye moving constantly—scanning, comparing, relating parts to one another, and to the whole. The more of these rhythm lines you find and put on paper, the sooner you will learn to see them automatically in your mind's eye and, thus, the sooner you will be able to dispense with them.

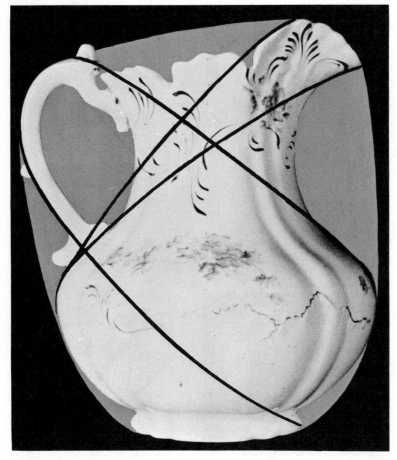

In your mind's eye
project the outlines
of the object
from side to side,
from top to bottom,
training your eyes to see
the rhythmic relation
of the outlines
to one another.

THE RHYTHM DRAWING

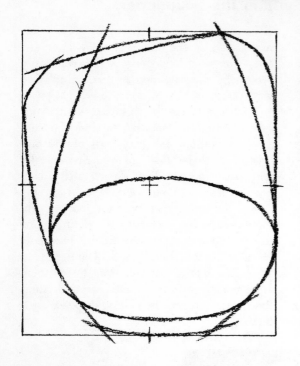

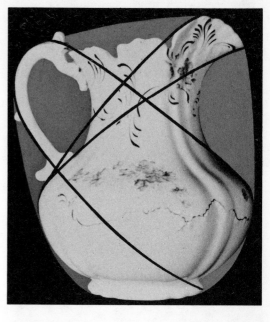

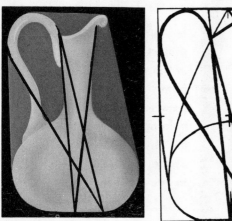

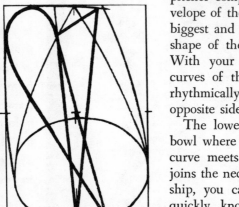

On top left is the drawing of the Dresden pitcher completed thus far—showing the envelope of the whole shape, and within it the biggest and next biggest shapes. To find the shape of the handle, study the photograph. With your X-ray eye, you note that the curves of the handle, when projected, join rhythmically with two key points on the opposite side of the pitcher.

The lower curve meets the curve of the bowl where it joins the base, and the upper curve meets the top of the bowl where it joins the neck. Having observed this relationship, you can now draw these two curves quickly, knowing that you have the correct

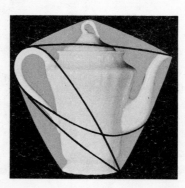

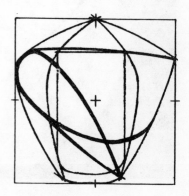

Connecting outlines from side to side, top to bottom.

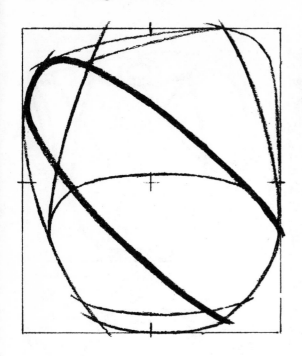 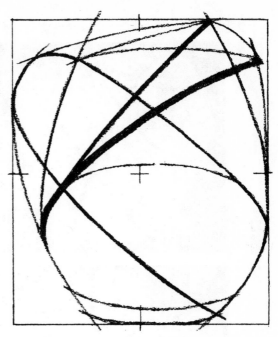

shape of the handle. In finding these big relationships, disregard the smaller shapes which are part of the handle. Remember that you are still thinking only of the big things; you will add the details later when you have completed the main structure, as explained on later pages.

Now that you have found the connecting rhythms going from left to right, look for the rhythms going from right to left, and up and down. You are still drawing with your lightest colored chalk, because many of these lines will not show in the finished drawing. These visualizing lines are to help establish the correct shape of the parts as related to the whole, as seen in the adjoining drawings.

In the drawing at far right, above, you can see how projecting the curves of the lip of the pitcher relates its shape to the bowl, going now from right to left. In similar manner, the rhythm lines are found on the other study subjects. Whenever possible, draw rhythms *connecting separate shapes* as well as the rhythm of each, as in the traditional teapot at far lower left.

As shown on the next pages, the combination of shapes and rhythms has already established all key points and relationships of the parts to the whole. Only a few minor lines are needed to complete the drawing.

 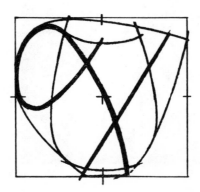

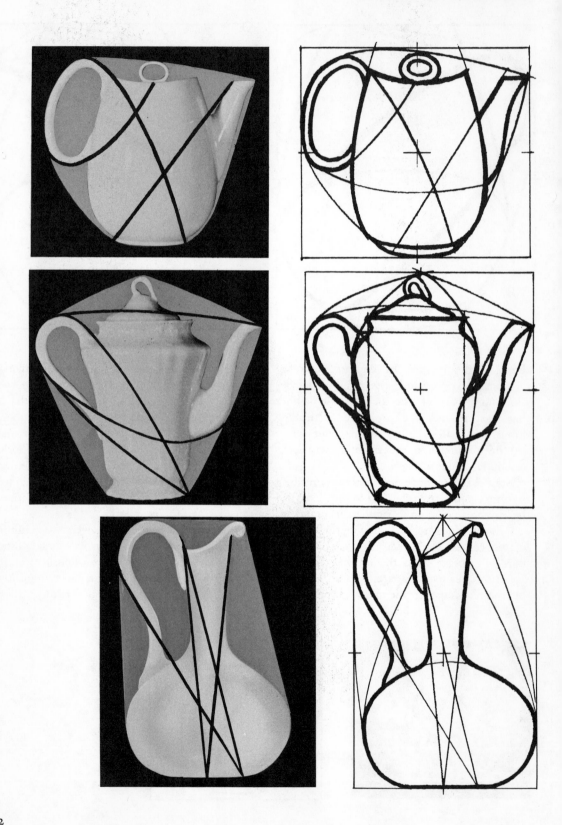

THE DRAWING

You now have all the parts of your subjects related to their whole shapes. All that is left to do is complete the outline by joining several key points already established. In the Dresden pitcher, all that is missing is the shape of the neck. Draw it in by making two symmetrical curves from the points where the rhythm lines cross the lines of the biggest and next biggest shapes. Notice now that the small lines that are needed to complete any actual shape are only slightly inside or outside of the floor plan made by the rhythm lines and shapes within the envelope.

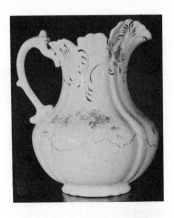

To make minor corrections, and bring out the entire outline of the subject, change from the light colored chalk to the next darker color, red. The temptation will be to draw this darker outline with a continuous line. This comes much later. For the present, redraw by going over your lines in the same way you started, using free-swinging separate lines, letting them cross over one another as shown in the drawing below.

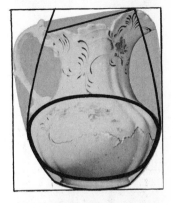

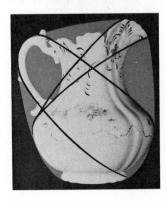

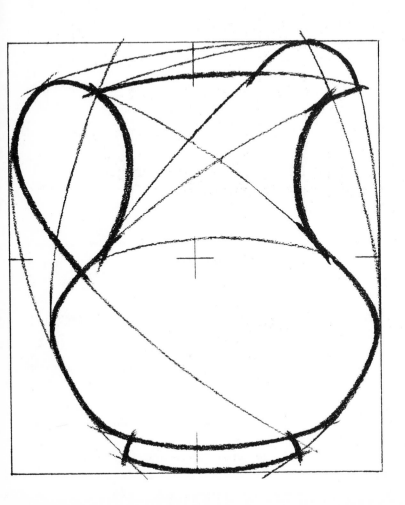

**The Basic Drawing method
is used for drawing detail
in the same way as for
drawing the whole object.**

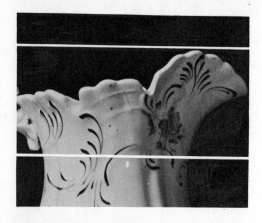

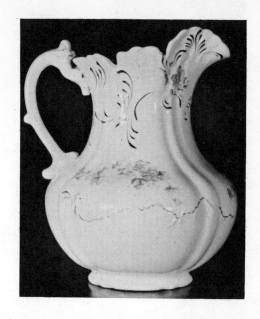

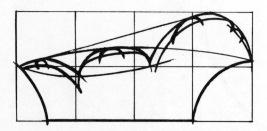

1. Enclose the area to be defined in detail within a rectangle, and locate the center.

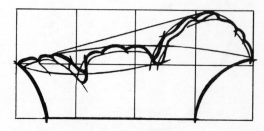

2. Draw the center lines within the rectangle and the biggest shape in relation to them.

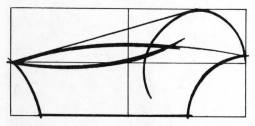

3. Using rhythm lines where possible, draw the next biggest shape containing detail.

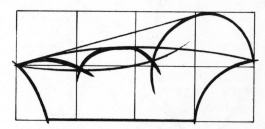

4. For greater accuracy, subdivide the quarter sections, and draw smaller unit shapes.

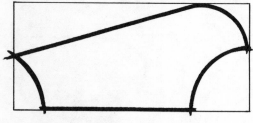

5. Guide lines following the main shapes help to locate the patterns of the detail.

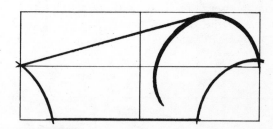

6. With all the main points established, complete the actual shapes of detail from the object.

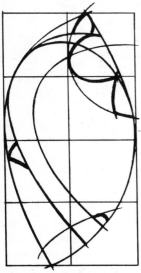

DRAWING DETAIL

You should not attempt to draw minor variations in the outline of an object until the basic shapes of the parts are completed in relation to the whole, in the manner previously described. Only then is it possible to concentrate on a small area, with the assurance that the shape of the area containing the detail is correct in relation to the whole object.

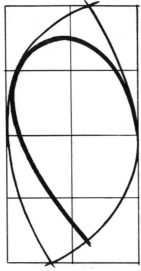

1. Enclose the envelope of the area in a rectangle.

2. Subdivide the rectangle and draw the biggest shape you see.

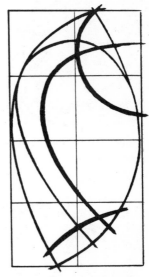

3. Complete the biggest shape and draw the smaller shapes.

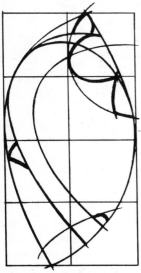

4. Draw the big patterns within the smaller shapes.

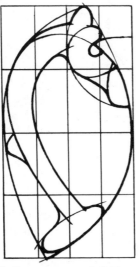

5. For accuracy, subdivide the rectangle again if needed.

6. Complete the detail within each shape, from the object.

ENVELOPES WITHIN ENVELOPES

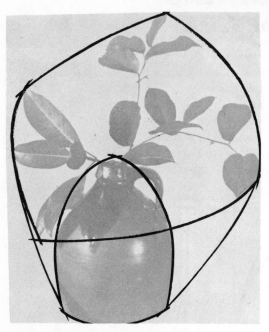

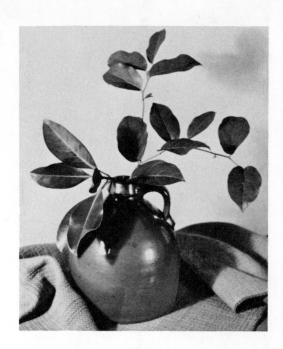

1. The biggest shape (all the leaves) and the next biggest shape (the jug) in the envelope.

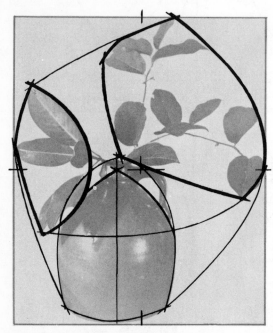

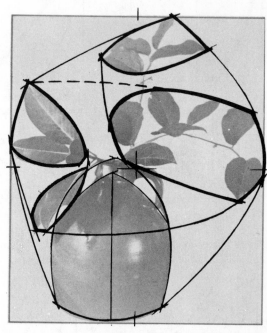

2. The biggest shape, containing all the leaves, is now an envelope within an envelope. Find within it, once more, the biggest shape and the next biggest. Do the same for the jug. With a symmetrical object, find its center line to help draw both sides alike.

3. After checking the shapes relative to the center points, proceed within each to subdivide into smaller and smaller envelopes. Remember to use your X-ray eye to see rhythm lines connecting shapes from side to side, top to bottom (dotted line).

DRAWING ONE OBJECT
WITH MANY PARTS

A single subject with many parts, such as a spray of leaves, at first glance may seem very difficult to draw correctly. *And it is, for almost everyone who has not learned to see properly by using the Basic Drawing method.* In fact, to draw such a subject accurately, by eye, is almost impossible for most people without the training in correct visualization and procedure you have learned thus far.

Your approach to this subject is exactly the same as for drawing a single object. The only difference is one of words. In a single object you usually have only a *big shape* and a *next biggest shape* within the envelope. Now, however, you have more shapes developing within each so that, in effect, smaller units may now each be called an *envelope within an envelope.*

Once you recognize this, it is a simple matter to proceed logically, step by step, in the same way as for a single object, working always from big envelopes down to smaller ones within them. To help see the smaller envelopes, hold your hand before you to block out such portions of the subject as will not be included.

When drawing natural subjects, such as a spray of leaves, using this Basic Drawing method, you will be fascinated with the usually unnoticed rhythms made by the overlapping of envelopes. There are usually many more of them to be found than you actually need to complete the drawing. For practice, you will help train your eye to constantly scan a subject, side to side and top to bottom, by drawing in as many envelopes as you find.

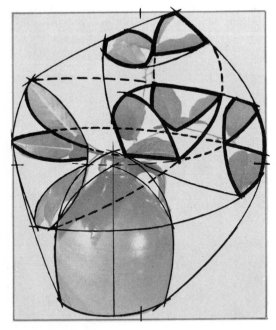

4. Working now within each small envelope, it is easy to find smaller shapes, always as envelopes first. Wherever they exist, look for rhythm lines (dotted lines) to establish the relation of distant points to one another. Do all these visualizing lines with light chalk.

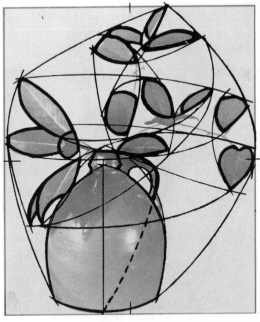

5. When the floor plan is completed, make any corrections with the red chalk by checking against a horizontal and a vertical by holding your rod up to the subject. Then draw in the shapes of each part of the subject as they actually appear to you.

DRAWING ONE OBJECT WITH MANY PARTS

SMALLER ENVELOPES WITHIN ENVELOPES

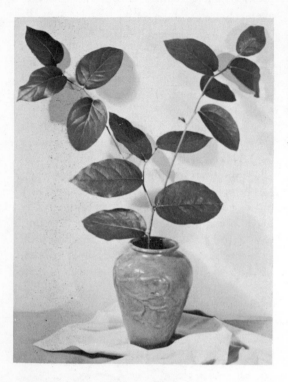

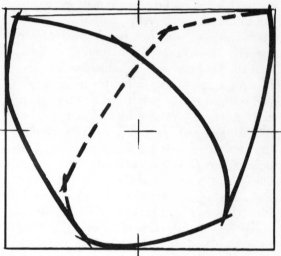

1. Enclose the envelope of all the leaves in a rectangle and find the center points, after checking proportions. The biggest and next biggest shapes within the envelope often overlap, with one portion being part of both shapes.

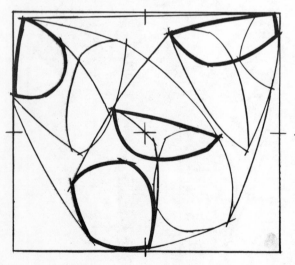

4. Still using light color chalk, find the smaller shapes made by units of two leaves. Notice that the rhythms now join the shapes within each envelope. Continue with this step until each leaf has been related to its neighbor.

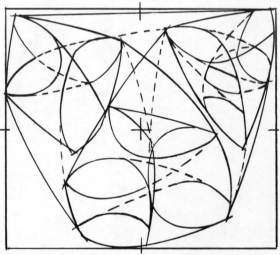

5. In this stage, all the leaves on the spray have been located by using your X-ray eye to see the rhythms joining them from side to side, shown by dotted lines. In addition, notice the many other rhythms that exist.

ARE FORMED BY X-RAY OR RHYTHM LINES

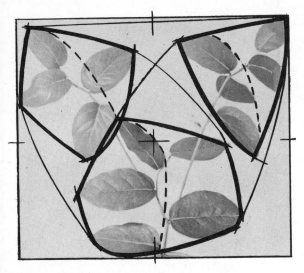

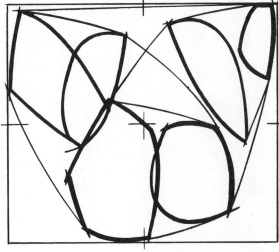

2. Now, thinking of each big shape as an envelope, draw the biggest and next biggest shapes within them. The dotted lines show the next smaller shapes. All these visualizing lines are made with the lightest colored chalk, drawn lightly.

3. Treat each shape as an envelope and divide it into parts in whatever way you see them most easily. For uniformity, units of three leaves are here drawn first, and then two-leaf units. Next stages will show similar divisions as alternates.

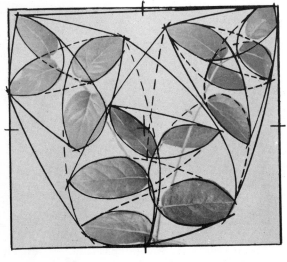

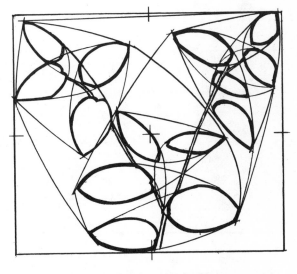

6. In this drawing over the photograph, you can see how the progression of envelopes within one another has established the location of each leaf in relation to the whole. Check key points vertically and horizontally.

7. With the floor plan completed, you now can draw the general shape of each leaf. Use your next darker colored chalk, red. The final step, the detailed drawing of each leaf, you will learn in Construction Drawing.

ENVELOPES WITHIN ENVELOPES

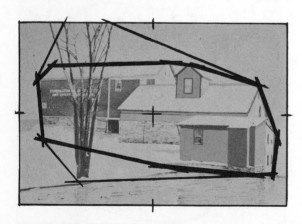

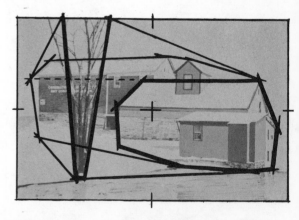

1. No matter what the subject, all drawings start with the envelope, which encloses all important objects. After checking it for proportion, look for and draw the biggest shape within it, which will be the largest group of objects that combine to form a unit. Now you have an envelope within an envelope.

2. From points already established, proceed with the next biggest shapes, which will be smaller groups of objects forming single units. Simplify an irregular object, such as a tree skeleton, into its basic structure by eliminating details, and in the same way, disregard minor elements on all objects.

DRAWING
GROUPS OF OBJECTS

If you have sufficiently practiced drawing single objects, and then single objects with many parts, drawing groups of objects will offer no problem. But only after you have learned to see with your mind's eye the envelope shapes and rhythms on X-ray connecting lines should you tackle a composition of objects of varying sizes and shapes.

As with any subject, no matter its nature, you always start with the envelope, which encloses the whole mass, and place this on your paper so that it makes a pleasing pattern as a whole shape in relation to the size of the working surface. Good composition starts here. Remember that a good drawing must be complete in every stage, starting with proper placement of the envelope within a given area. When each step is competently done, the drawing will grow naturally and stimulate you to complete it. It is always better to make a new start than to try to salvage a poor one.

After the envelope is properly placed and checked for proportion of height to width, study the subject. What you must look for

is the largest grouping of objects, which, when enclosed, will form the biggest shape within the envelope of the whole subject. *Remember, this does not mean the largest object in the group but, rather, a combination of objects which together make a complete unit.*

Once the biggest shape has been visualized, draw it with straight and/or curved lines, according to the subject. Now look for the next biggest shape, which will be a smaller grouping of objects, *that make a complete unit.* This may or may not overlap the big shape. Now you can proceed, as with a single object with many parts, drawing envelopes within envelopes until all the parts are formed. Here, the parts are whole objects.

It is more important to develop the habit of seeing relationships by seeing and drawing envelopes within envelopes than to hurry to draw the outlines of single objects. By drawing the envelopes first, you are also marking the size and position of each object in the group as it appears from your station point, which is to say, in "perspective."

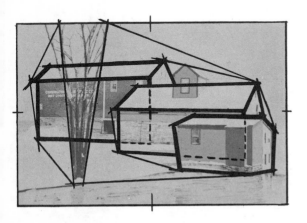

3. Continue now to make smaller envelopes within envelopes, working from the larger down to the very smallest. When two masses overlap, it is helpful to draw the complete shape of each, even though all the lines will not appear in the final drawing, shown here by dotted lines.

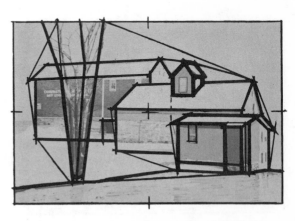

4. Before adding minor shapes, check the location of major points vertically and horizontally by holding your rod up to the subject. Remember not to check at an angle. Still working in a big way, find the basic shapes of the parts of the objects until the floor plan is completed.

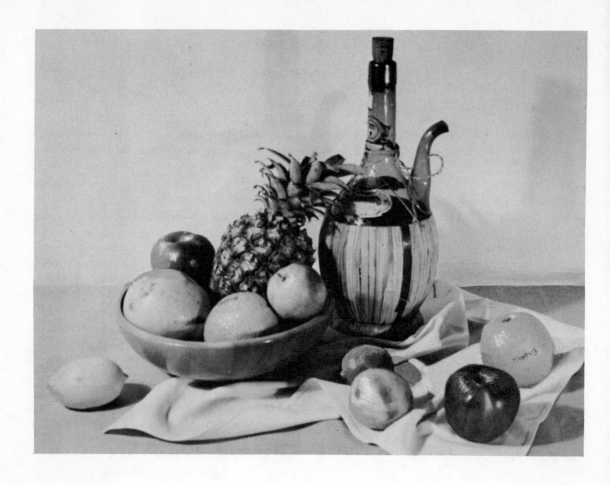

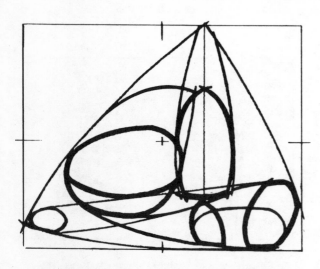
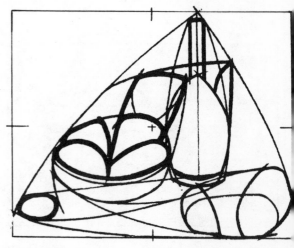

3. Always working from larger shapes down, continue, within each envelope, to find the basic shapes, or lesser groups. Notice that the whole shape of a bottle or vase is an envelope, including the neck. The bowl part of the bottle is the big shape in its envelope.

4. Continue to locate smaller units in each envelope, and also include parts of objects which may be considered variable factors and not important enough to include in the envelope. Here, the spout on the bottle would not be visible when behind the neck.

DRAWING GROUPS OF OBJECTS

The Largest Group of Objects and the Next Largest Make Envelopes within the Envelope.

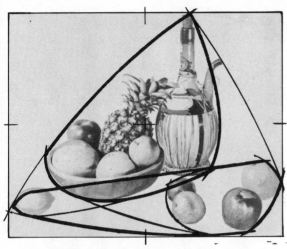

1. Within the envelope enclosing the whole still life are three shapes overlapping one another. The largest contains all the objects except the lemon at left; next largest, the bowl of fruit and bottle; and last, all the fruit in the foreground. *You must use your X-ray eye to visualize envelopes enclosing related objects, however far apart.*

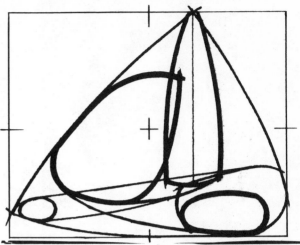

2. After checking each big shape relative to the center points and to each other, think of each as an envelope, and work within them one by one. Again, in each, find the biggest shape and then the next biggest. When drawing a symmetrical object like a bottle, draw in its center line to help make the sides equal.

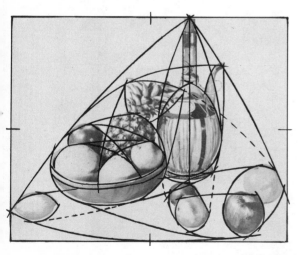

5. Work with your lightest colored chalk until all the envelopes have been formed. To make corrections after checking laterally and vertically, use the next darker color, red. Shown above are all the envelope lines, and other rhythm lines not needed (dotted lines).

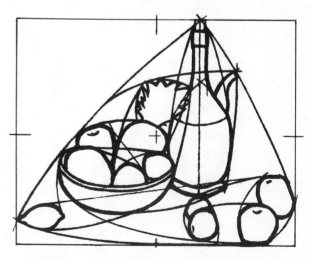

6. Using the *red* chalk, draw in the general shape of each object in the positions located by the envelope lines. Under the red chalk, the lighter color will disappear. Drapery, unless it is part of an envelope, is added last, since it may be only partly needed.

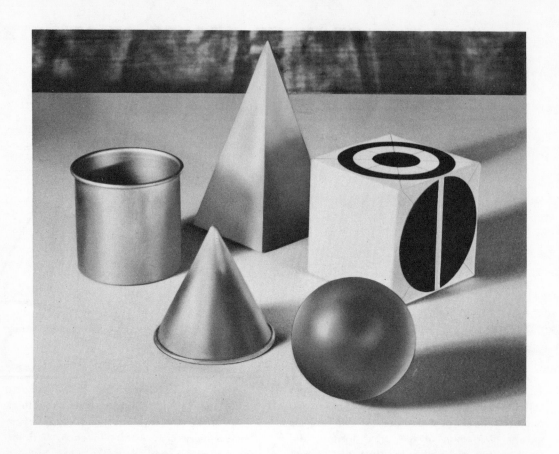

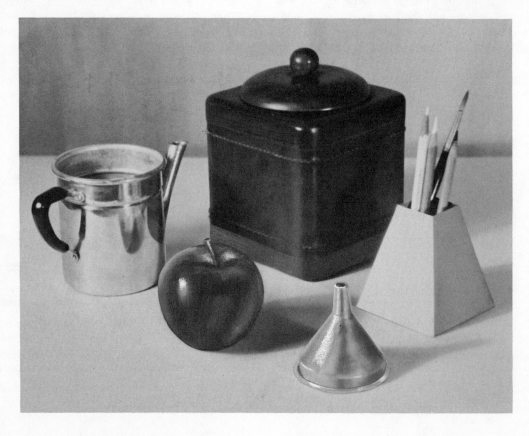

THE NATURE OF SOLID FORM

When you use the Basic Drawing method to draw the appearance of an object or a group of objects, you arrive at the correct representation by simply drawing the shapes as they appear to you, in a logical sequence already described. When, however, you wish to go further with your drawing by adding light and shade, it becomes important to know about the basic geometric solid structure underlying all objects that have depth.

In the photograph opposite, above, are the five basic solids: the cube and pyramid, the sphere, cylinder, and cone. Below it are five familiar objects whose basic shapes resemble one of the five solids. But notice that, although simple in shape, they combine parts of several basic solids. The funnel, for example, is made up of a part of a cone and portions of cylinders of different sizes.

More complex objects naturally combine more portions of the various solids. It is for this reason that a portrait is so difficult. The features represent a most varied and complex arrangement of small portions of different solids overlapping one another. You will be helped tremendously later on if you spend time studying the construction of the solids, and drawing objects resembling them in all positions and at different eye levels.

You will find such study very rewarding in the study of geometry, drawing a cross section, sculpting a statue, designing an interior, planning a building. The ability to visualize and draw any geometric solid or parts of it, in any position or distance, is part of the development of your engineering sense. It contributes to your sensitivity to the third dimension of solid form—depth.

DESCRIPTION OF THE SOLIDS

THE CUBE: A regular body of six equal and square sides, containing equal angles, each side being at right angles to those next to it. Related to it is the rectangular solid, or box. In a box, only the opposite sides are equal and not necessarily square. But just as in the cube, the sides are always at right angles to those adjoining, and all sides have equal, or right angles.

The box shape is our most useful construction solid because it is based upon a square body, the cube. Very often it is helpful to measure a long subject in terms of cubes— that is, as one and a half, two and a half cubes, and so on.

THE PYRAMID: A body also related to the cube since its base is flat and straight sided. This base may be three, four, or many sided. The sides, however, are always triangles which meet at a common point above the base, called the *vertex*. When the vertex is directly over the center of the base, it is a right pyramid; if at a point other than center above the base, it is a slanted pyramid.

THE SPHERE: A completely round body, like a globe, whose surface is everywhere equally distant from an imaginary point within it called the center. Thus, all straight lines drawn through the center that reach opposite surfaces of the sphere will be equal in length. Such lines are called diameters. In practice we usually use only two, at right angles to one another. As such, these two diameters are also known as the vertical and horizontal axes.

THE CYLINDER: A long circular body of uniform diameter, like a glass, whose ends form equal and parallel circles. We may therefore think of it as layers of equal circles, one upon the other. A line drawn through the centers of these circles is the axis of the cylinder, and the sides of the cylinder are parallel to it, represented also by straight lines joining the top and bottom diameters.

THE CONE: A body, like a funnel, related to the cylinder, because its base is a circle. Unlike the cylinder, however, the layers of circles making up the cone grow progressively smaller in diameter until they end in a point above the base. The sides therefore taper evenly to end at this point called the vertex. When the vertex is directly above the center of the circle at the base it is a right (angle) cone, and both sides are equal as in a pyramid. When the vertex is off center, it is a slanted cone, and the sides will be unequal.

THE CUBE:

basic building block

When the Egyptians learned how to make a perfect right angle on the ground, they started the sciences of architecture and geometry. In the same way, the nature of the cube provides the basis for building solid bodies of many shapes, including round ones. For this reason, you will profit greatly from time spent learning to draw the cube as seen in

any position or angle, at all eye levels. Once the cube itself is properly represented in a given position, you will be able to use its construction properties to build many other bodies within it.

As a solid body, the cube has six square sides of the same size, only three of which can be seen at a time. For construction pur-

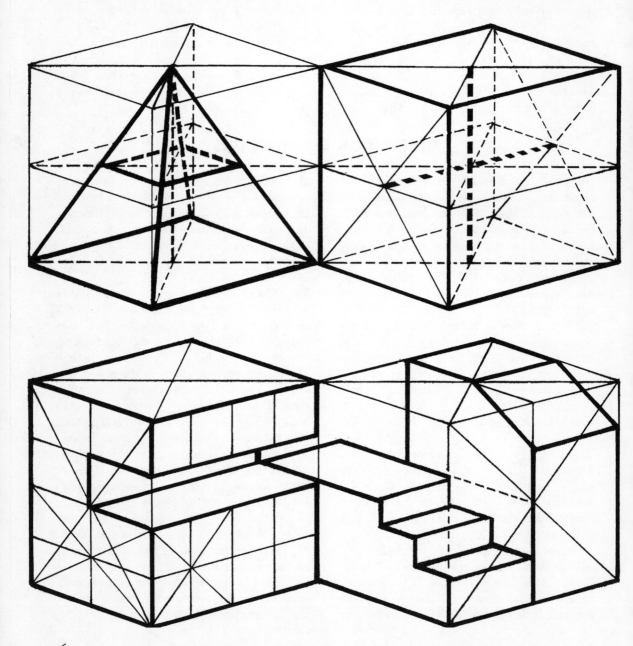

for constructing other solid bodies

poses, however, you must imagine the cube as transparent. In the illustrations, the invisible but necessary lines are shown as dotted lines. Think of a cube as square layers of cardboard resting one upon the other to make up the horizontal planes, or standing up parallel to one another to make up the vertical planes. You can now translate any given solid body into portions of the cube. For your purposes, the most useful characteristic of the cube, or of any rectangular solid, is the fact that diagonals drawn from opposite corners of any face intersect at a point which is the center of that face. Therefore, lines drawn through the center point parallel to the sides will divide that face into halves. Successive use of diagonals then will help to divide any given area into as many segments as needed.

The second most useful characteristic of the cube, and for most other solid bodies, is the lines connecting the center points of opposite faces, shown opposite page, top right. Naturally, since such lines are within the solid body they are invisible, but very necessary to construction. They are known as the axes of the solid. Normally you do not need more than two such axes, the vertical and the horizontal. You should always find the axes needed, even for an irregular object, and indicate them on your drawing even though they will not appear later. They will help in constructing the parts of the solid.

The illustrations show the construction of familiar, straight-sided solid bodies. In the pyramid (opposite, top left) you can see why you should draw the whole solid in order to properly find a portion of it. In the solids resembling buildings (opposite, bottom) notice the successive use of diagonals to divide a given area, and also the formation of a slanted plane by slicing off a corner of the cube. On this page notice the relation of the roof shapes to the diagonals on the faces of the whole cube.

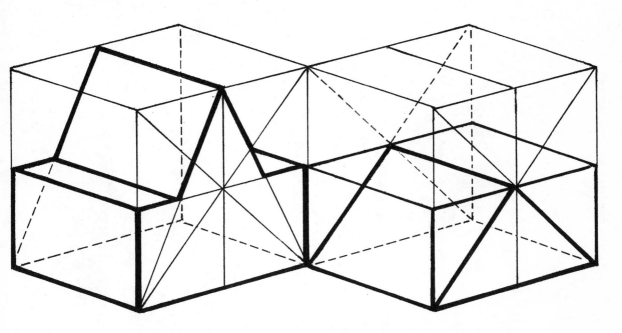

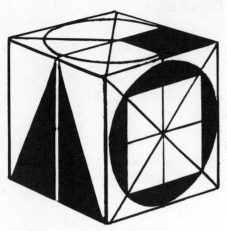

On this page are the three basic plane-geometry shapes, the rectangle, triangle, and circle, drawn on the surfaces of the cube. In their various positions they represent the appearance of the sides or bases of familiar objects of similar nature when seen at an angle. Just as drawing the cube itself in many positions develops your engineering sense, so drawing the appearance of these shapes on the cube itself, as seen from different positions and eye levels, will further develop your feeling for form in space.

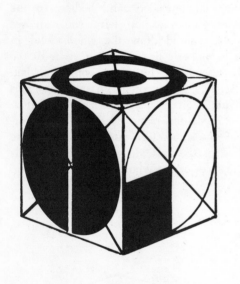

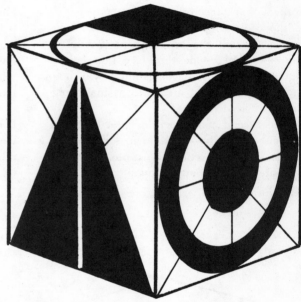

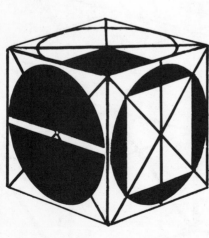

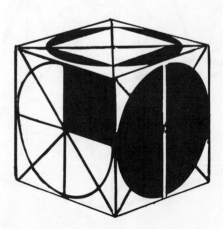

ON THE FACES OF THE CUBE

Going further with geometric shapes on a plane or flat surface, on this page are various designs made up of basic units in combination. Notice how the diagonals and center lines through them provide the points needed to draw the shapes. Combinations such as these also appear frequently in subjects for drawing. Find or construct a square box, and draw the elementary shapes shown on opposite page on its surfaces. Then practice drawing from it in many different positions.

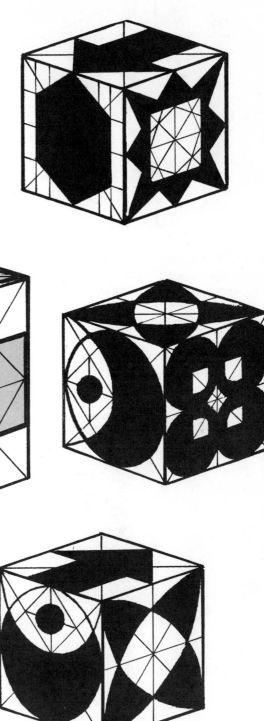

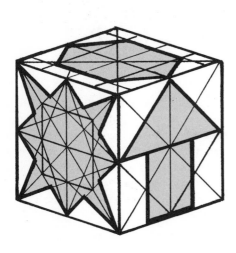

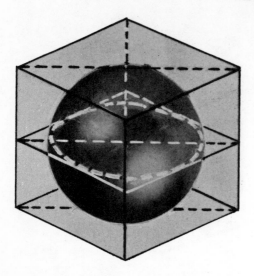 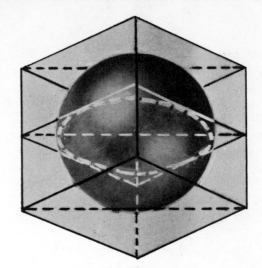

THE SPHERE: When you draw a sphere, or globe, you represent it by a circle. By its nature, only one point on the surface of the sphere touches each face of the cube. Every portion of the sphere is receding from you, except the one nearest you. In normal lighting, the lightest portion of any round object is always within it, never on the edge.

In practice it is a *portion* of a sphere, like a bowl, that you more often draw. The dotted lines show how the circle of half a sphere relates to the plane of the cube enclosing it. Since a circle seen at an angle appears as an ellipse, here you can see why the diameters of an ellipse are not equal as they are in a circle.

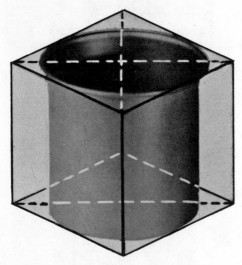 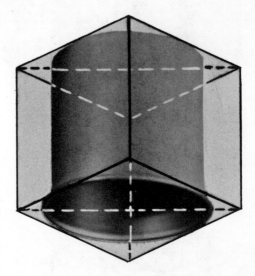

THE CYLINDER: By definition, a right cylinder has ends which are circles of equal diameter, at right angles to the axis (the line through its center parallel to the sides). To construct it, find the length of the long diameter of the ellipse you can see entirely. Parallel lines drawn downward or upward from this length will give the other long diameter while establishing the sides. To

complete the ellipses at either end, *draw the short diameters at right angles to the long ones,* and mark off their length in relation to the planes containing them. This step is the same as for drawing a portion of a sphere. How the short diameters vary depends on distance from eye level, explained in the Perspective section.

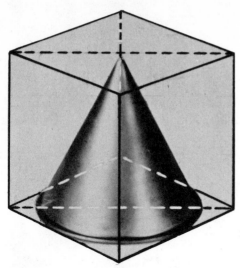 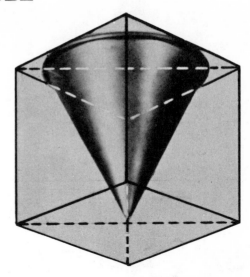

THE CONE: If you think of a right cone as a portion of a right cylinder, the construction within a cube is simple. The base of the cone is a circle, just as in the cylinder. Therefore draw it as a complete ellipse within the plane containing it, after marking off its long and short diameters. The diagonals on the opposite face of the cube give you the center point from which you can draw straight lines to the ends of the long diameter of the ellipse of the base. Since most objects you draw that resemble a cone are not complete cones, you will find it helpful to first draw the whole shape and then cut off to the part wanted and draw the top ellipse on that plane.

THE PYRAMID: Most pyramid shapes we draw are four sided, though there may be more, or only three sides. Because the base of any pyramid is a flat or plane surface, we can find its center by diagonals from opposite corners of the base of the cube containing it. For a right pyramid, draw a vertical line upward from the center point to the height of the pyramid, or vertex, if it is higher than a cube. Lines drawn from the vertex to the corners of the base form the triangular sides of the pyramid. If the shape you want is not a complete pyramid, then cut off at the height of its top plane, as in the illustration.

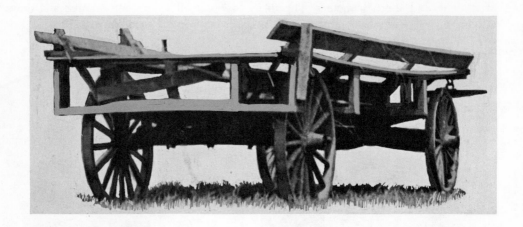

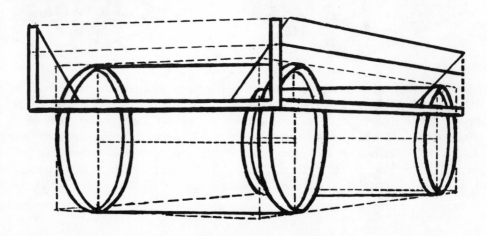

TRANSLATING FAMILIAR SUBJECTS
INTO THEIR BASIC GEOMETRIC BODIES

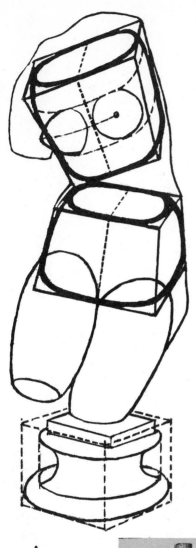

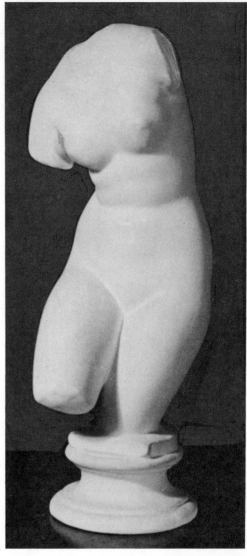

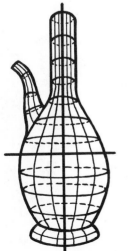

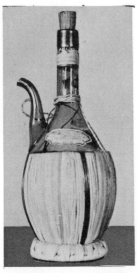

Whenever you can,
complete the shape
of any solid body
you can identify,
even though not all of it
will appear in
the finished drawing.

THE MEANING OF SURFACE PLANES:

We use the word "plane" when referring to any flat or level surface. As such it may be very large, as the ground in a landscape, or very small, as the tiniest part of a fruit. Ordinarily we think of a plane as being only level or horizontal, like the top of a table, or upright or vertical. But any flat surface is a plane, however it is inclined.

To understand this, hold a piece of cardboard in front of you and think of its borders as defining the edges of a plane. Now tilt it forward and back, then revolve it in a circle vertically and horizontally. The cardboard in each position represents a plane as it would

appear as part of an object. Your problem is to learn to see any object as though it were made of pieces of cardboard joined together.

When you make a construction drawing of the outside surfaces of an object, such as the pepper illustrated far right, your straight lines are indicating the outside edges of a plane. The missing edges are inside the boundaries of the object. In natural objects, usually not symmetrical, they may or may not be parallel to the ones already drawn. For simplicity in demonstration, the planes on the pepper illustrated have been drawn as though each plane had parallel sides.

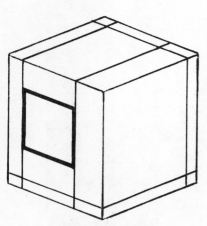

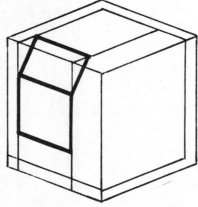

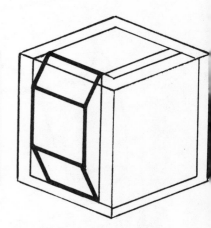

1. The easiest plane to see on the sides is the one parallel to the face of the cube; its edges are defined by straight lines which end where the shape of the object changes direction.

2. The slanted plane follows the change in direction of the surface; one long side is also the edge of the plane already found. This plane cuts a corner off the cube.

3. Again following the direction of the object's outlines, the slanted plane below matches the one above. All smaller planes will be added later, within each plane.

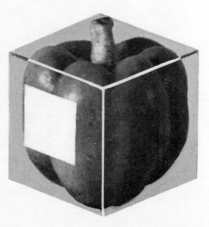

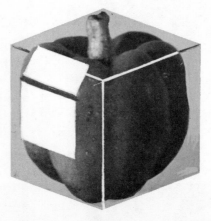

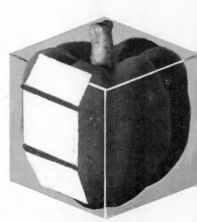

HOW TO FIND THEM

When constructed this way, the complete shape represents the basic, geometrical solid body. The more often you indicate the basic body underneath the objects you draw, the better your understanding of them when adding light and shade.

Illustrated here is the step-by-step analysis of the main planes on the surface of a familiar natural object, a green pepper. To make them easier to identify, they are drawn in relation to a cube. The vertical and horizontal planes naturally are parallel to the faces of the cube. The slanted planes are formed by cutting corners off the cube. Each

plane then is defined by its edges, as determined by the object.

Now notice that where the edges of planes meet they form corners, or points. Such corners, or points, are made when two straight lines cross one another. For this reason, it is necessary to convert the first visualization of a subject into a series of intersecting straight lines, because rounded lines provide no corner points. This conversion from rounded to straight lines is called Construction Drawing because it helps us to find the planes on the object as well as to more accurately describe its true nature, as described later.

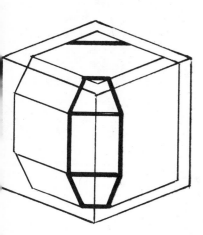

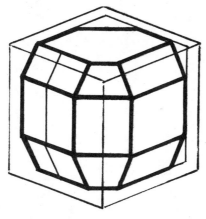

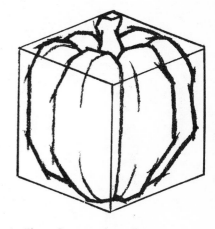

4. The center frontal plane is parallel to you, as are the upper and lower frontal planes, though slanted backwards. The top edge of the plane in back is parallel to the one in front.

5. Complete the geometrical body by adding the remaining comparable planes. The light line represents the divider for the smaller planes, added later.

6. The Construction Drawing converts the curved lines of the first statement into straight lines which cross one another to mark the sides of each plane.

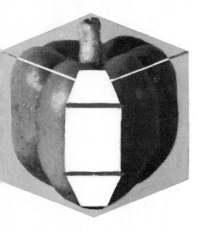

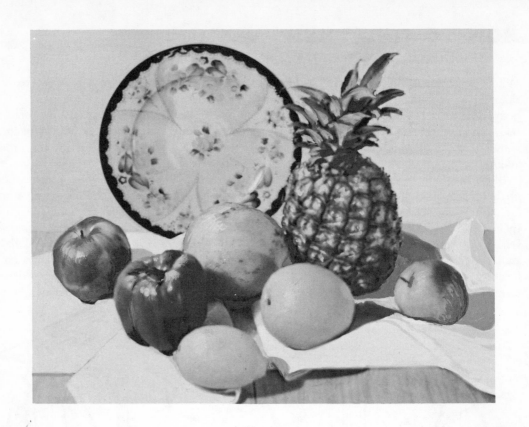

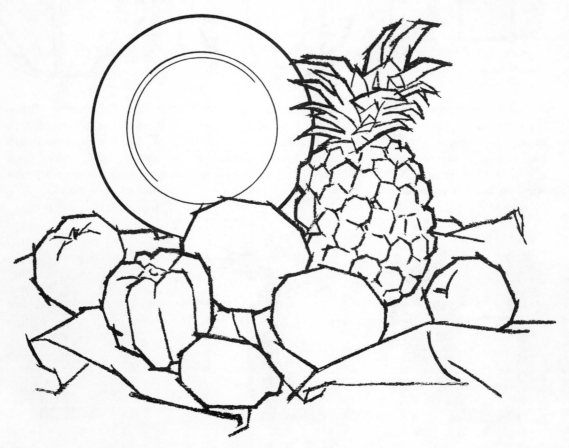

CONSTRUCTION DRAWING

Your Eagle Eye is very keen, and sees the smallest change in direction of the outlines of the object.

A definition of an artist is one who creates a work of esthetic value as the result of skill, observation, and experience. One part of your skill is physical and, as in any field, comes from constant practice. The other part is visual, and is developed with training. Thus far you have learned to see in two ways—using your mind's eye to see whole shapes even though they do not exist in fact, and using your X-ray eye to see the rhythms that connect parts and shapes with one another. Now you must learn to see in still another way, *by developing your Eagle Eye.*

The eagle is known for its unusually sharp vision, by which he can see very small objects from great heights. In your case, you must now learn to see not small objects, but the smallest changes in direction of the outlines of the object. This is the stage called Construction Drawing. When the position and size of the elements in your composition have been properly established by using the Basic Drawing method, you are free to concentrate on each object in detail.

WHY WE USE STRAIGHT LINES FOR CONSTRUCTION DRAWING

In the drawing above you can see that any arc or curved line may be reproduced in effect by overlapping smaller and smaller straight lines. Naturally, when an object is *perfectly* round, as a plate or globe or bowl, you would represent it by an even curve, as in the drawing opposite. Such objects are usually man-made, and perfectly symmetrical. However, most natural objects, when closely observed, are seen to be imperfect in symmetry. Looked at casually, an orange appears round. But when studied carefully, its outlines are more accurately described with straight lines than curves. When drawn

this way, the orange still appears almost round, but in addition has the character of an orange rather than an apple, and is also a different orange from another next to it.

STRAIGHT LINES IN CONSTRUCTION DEFINE SURFACE PLANES

When your drawing is ready to convert to a construction, shift to a darker-colored chalk. Using always only a *sharp* corner of the chalk, and, observing very closely, redraw the outlines of each object in terms of straight lines that cross one another where they meet. As you learned in the preceding pages, the points made by the intersection of two straight lines going in different directions define one outside edge of a plane on the surface of the object. The inside opposite edge of such a plane is within the object, to be marked off later if needed.

When making a construction drawing, be sure to make each line only as long as it continues straight. Where the outline changes direction, make another separate straight line.

Construction Drawing is different
from Outline, or Contour, drawing.

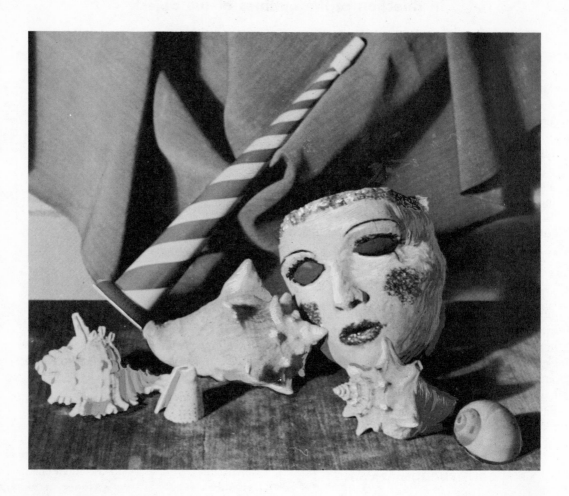

It is natural for almost everyone to want to be an expert as soon as possible, preferably without working for it. That is why, in drawing, most students are in such a hurry to complete the outlines of a subject. Actually, the ability to draw any subject correctly as an outline or contour only, without first making preliminary lines, is the ultimate in skill.

A good outline drawing portrays the subject in true positions and shapes, *without any excess lines*. Also each portion of the outline should reveal the character of the body it encloses, as expressively as possible. To be able to do this, then, requires not only a keen and well-trained eye, but also skill in drawing plus a complete understanding of the nature of the subject. For these reasons, you should not attempt direct contour drawing until you have had considerable practice making construction drawings of all kinds of subjects.

A construction drawing, by definition, reveals the basic nature of an object *as a solid body*. As such, then, you should try to indicate not only the outside shape of an object *but also the formation of the parts within it*. These lines inside disappear if you later add light and shade, but in any case they help you to better understand the subject.

Directly below is a construction drawing of the subject on the opposite page. The lightest lines show the envelopes within the envelopes by means of which the various objects were located in relation to one another. Within the envelope of each object, other light lines show the needed geometry of the object. A few minutes spent on this step will ensure your locating details on the surface of each object in proper relation to the whole. *On rounded shapes find the main axis first.* Lines drawn at right angles to it will serve as diameters for ellipses.

CONSTRUCT FIRST . . .

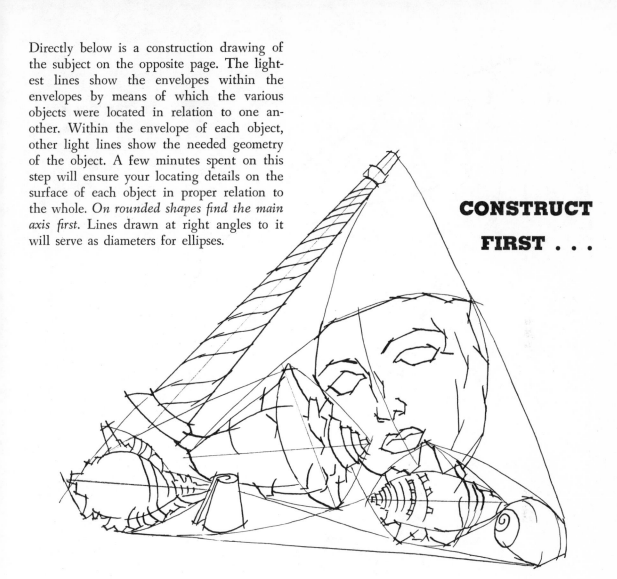

In the actual construction of the outlines of each shape, notice that every single straight line (no matter how small) that goes in a different direction from the one meeting it is indicated as crossing over its neighbors. This angular quality helps give the subject the solidity of architecture. Compared to it, the rounded lines of the first, or rhythm, drawing appear rubbery and soft.

When a construction drawing is to be used for adding light and shade, make your lines with your *brown chalk,* quite crisp and dark. Otherwise work lightly in a lighter color. At right, you can see how the final drawing combines curved and straight lines to express the true character of the subject, the result of a combination of rhythm and construction.

DRAW LATER

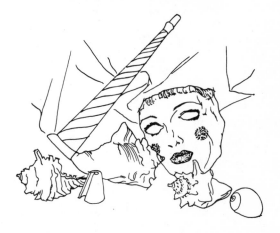

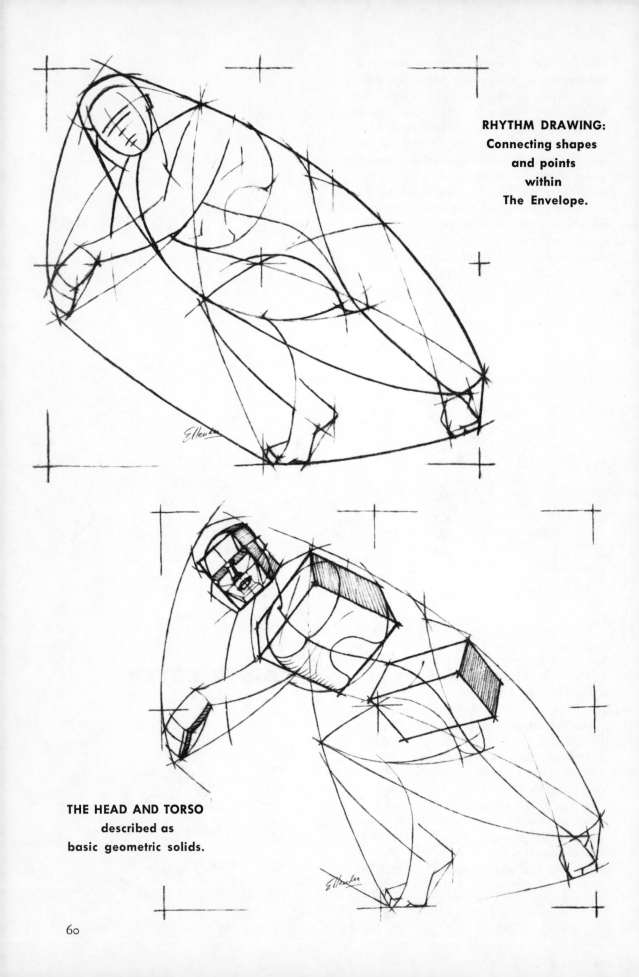

RHYTHM DRAWING:
Connecting shapes
and points
within
The Envelope.

THE HEAD AND TORSO
described as
basic geometric solids.

Making construction drawings of simple objects usually poses no great problems for you because their basic shapes and surfaces are familiar and easily understood. The human figure, however, is more complicated, being an assembly of geometric bodies of many sizes and shapes, on top of which are the muscles. A construction drawing of the figure is presented here to show that, by applying the Basic Drawing method of visualization learned thus far, you are equipped to begin further study and observation of the anatomy of the human figure.

CONSTRUCTION DRAWING OF THE FIGURE

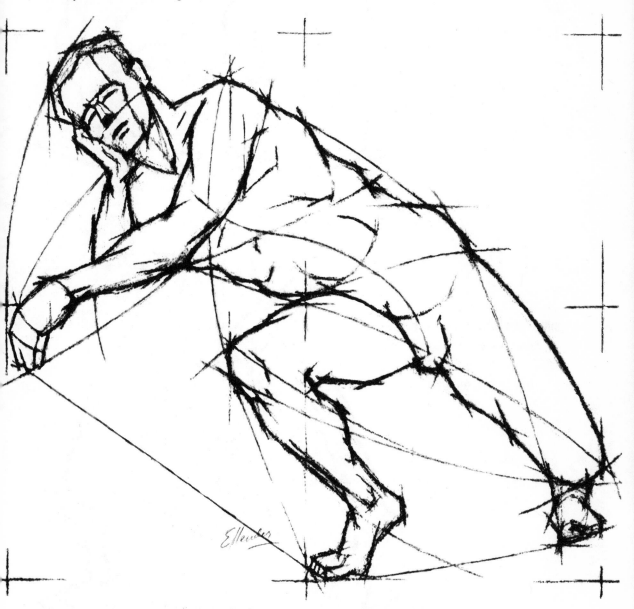

In the section on Drawing the Figure you will find an analysis of the basic shapes and their movements.

**DRAWING
USING CURVED LINES ONLY**
gives a rubbery
bloated outline.

**DRAWING
USING STRAIGHT LINES ONLY**
gives great strength
and solidity
but is too angular.

CONTOUR DRAWING

by definition—the line or lines which represent the outline of any figure or body, its form being determined by the shape of the body.

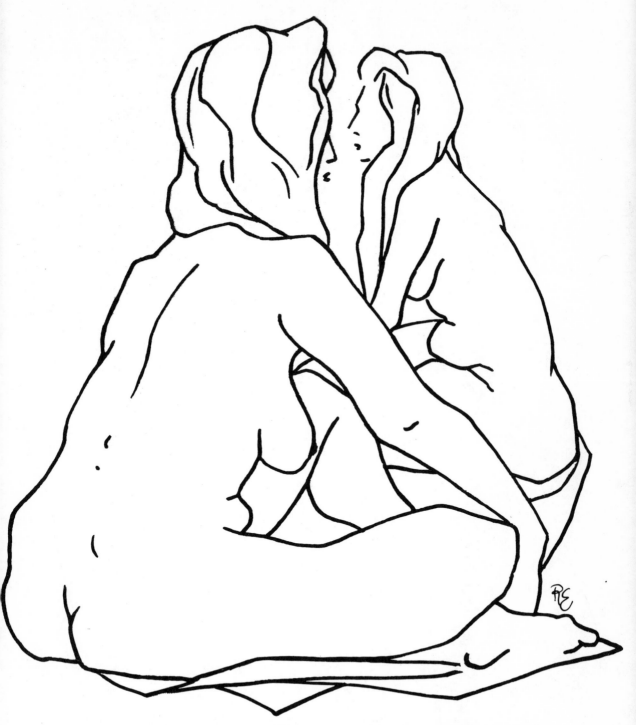

Contour Drawing based on both rhythm and construction lines develops an outline which gives greatest clarity to the definition of form by using both
CURVED AND STRAIGHT LINES.

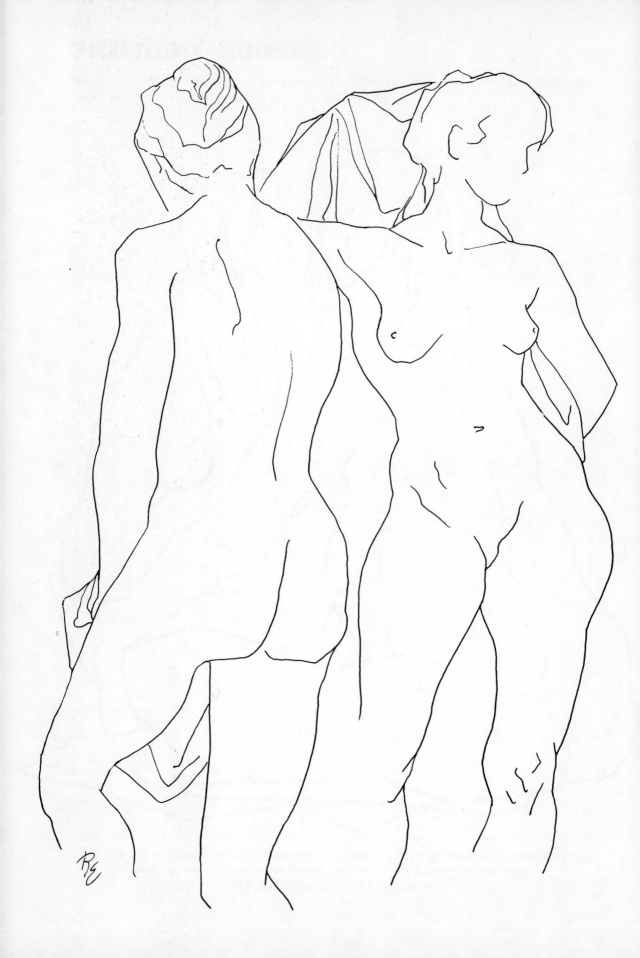

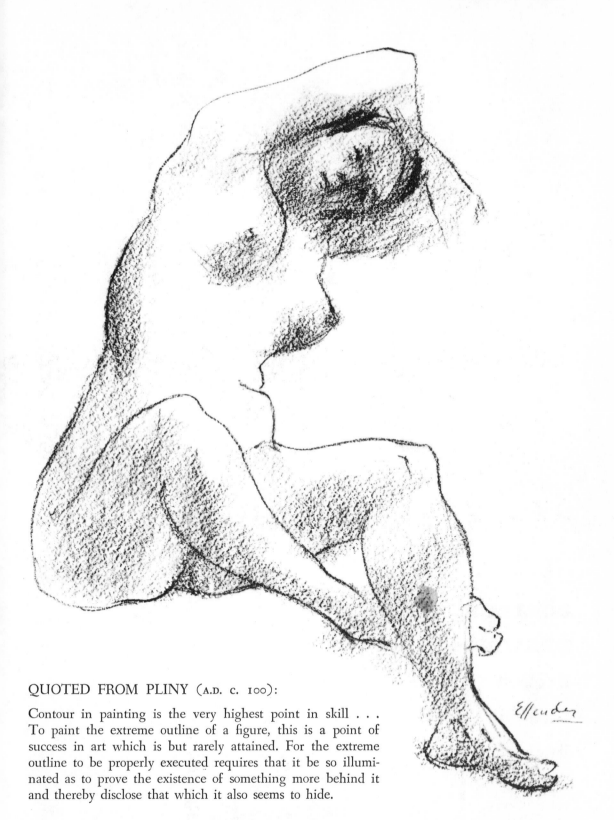

QUOTED FROM PLINY (A.D. C. 100):

Contour in painting is the very highest point in skill . . .
To paint the extreme outline of a figure, this is a point of
success in art which is but rarely attained. For the extreme
outline to be properly executed requires that it be so illumi-
nated as to prove the existence of something more behind it
and thereby disclose that which it also seems to hide.

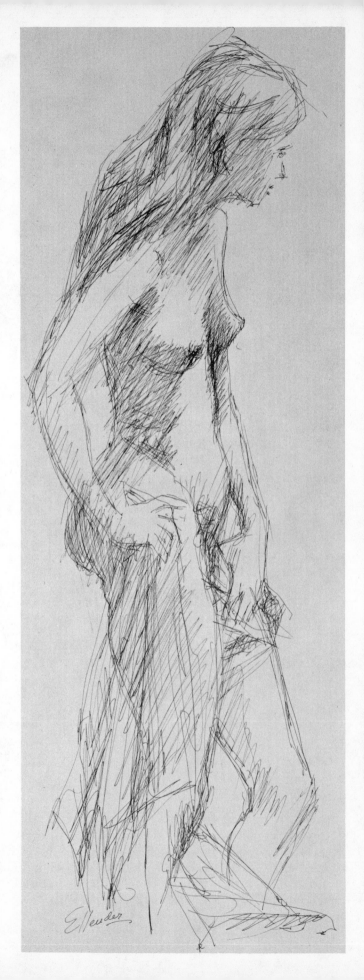

CONTOUR DRAWING: Broken (sketch) line

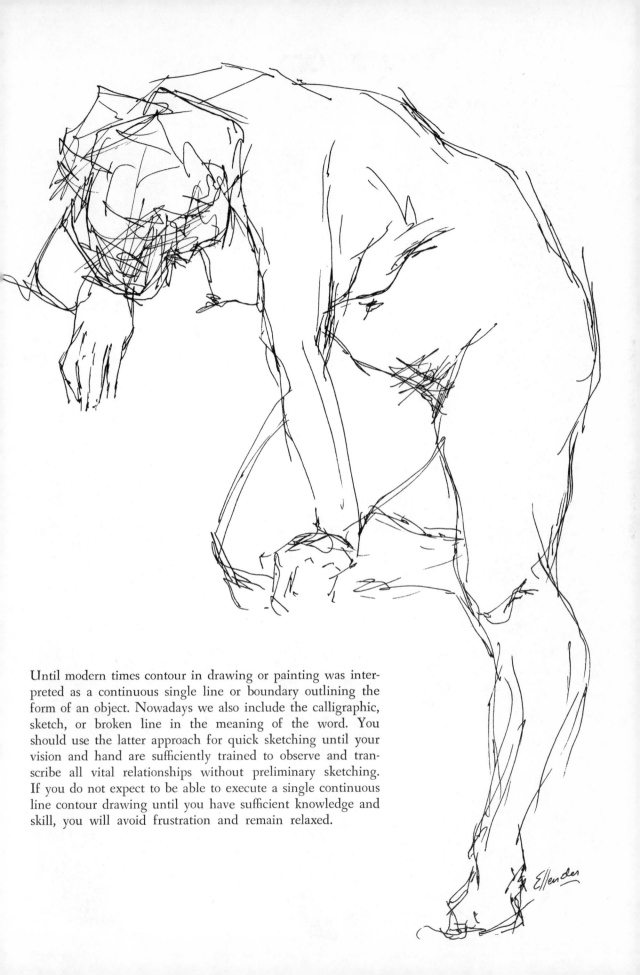

Until modern times contour in drawing or painting was interpreted as a continuous single line or boundary outlining the form of an object. Nowadays we also include the calligraphic, sketch, or broken line in the meaning of the word. You should use the latter approach for quick sketching until your vision and hand are sufficiently trained to observe and transcribe all vital relationships without preliminary sketching. If you do not expect to be able to execute a single continuous line contour drawing until you have sufficient knowledge and skill, you will avoid frustration and remain relaxed.

LIGHT AND SHADE

adding the third dimension—Depth

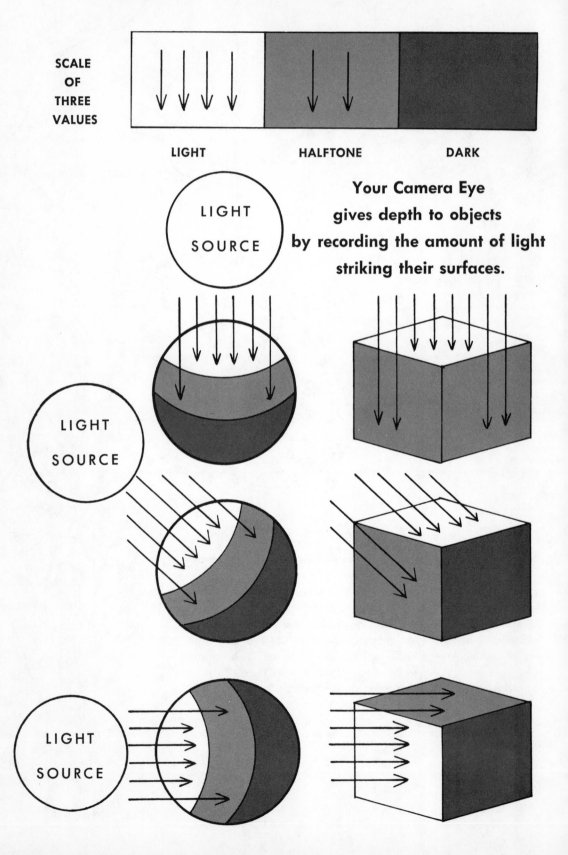

SCALE OF THREE VALUES

LIGHT HALFTONE DARK

LIGHT SOURCE

Your Camera Eye gives depth to objects by recording the amount of light striking their surfaces.

LIGHT SOURCE

LIGHT SOURCE

In the traditional sense, painting means the representation of three dimensions—length, width, and depth—on a two-dimensional surface. The illusion of depths is created by modeling the forms in tones from dark to light. To correctly model a form therefore requires good drawing first—particularly *construction drawing*, which indicates the position in space of the various planes making up the surface of an object. The position of a plane in relation to the source of light determines the amount of light it will receive.

This is easy to understand when you think of light as a series of arrows parallel to one another, traveling in straight lines from the source until they strike the surfaces of an object. Planes that are at right angles to the arrows, or nearly so, will receive maximum light, planes which we call the *Lights*. Planes turned completely away from the light will get none at all, and such planes we call the *Darks*. Planes that are parallel to the arrows, or nearly so, will get only half the light, and such planes we call *Halftones*. By turning a piece of white board in relation to a single light source you can see this clearly.

SCALES OF TONES OR VALUES

When referring to the amount of light reflected from the surfaces of an object, the artist uses the words tones and values synonymously. If you imagine a ribbon tinted evenly from white through gray to black, you realize that such a scale could be divided into any number of parts, perhaps a hundred, or even more. In general use by artists, however, a scale of ten values is sufficient. For purposes of study, and also in making a first statement when shading a subject, it is better to use a more limited scale. Such a scale needs at most four values, two in the light, two in the dark. To begin with, start with only three values, shown on the opposite page. The reasons for the extra value in the light follows on the next pages. Since your approach should always be to work from the largest concept down to the smallest, leave all minor variations in tone for the finishing touches. Using a scale of three values, use your red chalk, applied lightly, to indicate the value of halftones, and the dark brown chalk for the darks. Leave all areas in the light open, or white. To apply the chalk use the *sides* of a small length.

THE DARKS GIVE DEPTH TO FORM

In the broadest sense, when referring to the shading of an object, every part in the light we call the lights, and every part turned away from the light we call the darks—whether halftone or darker. As you will see later, establishing the pattern of the darks immediately adds the illusion of depth to the drawing, even without any modeling in the lights. In picturemaking it is the pattern of the darks which make the composition, not the lights. For simplicity in elementary study you are using several colors of chalk to represent the different values in principle. But bear in mind later on that, *though the pattern of the darks always separates the planes in the light from those out of it*, this pattern will be quite light in value when the objects are light-colored in bright light. For this reason you should not work in the lights until you have found the correct values for the pattern of the darks in relation to the kind of lighting and the color of the objects.

TRANSLATING COLORS INTO BLACK AND WHITE

Many animals, dogs for instance, do not see color, only shades and tints of gray. As a student, your problem for a long time will be to see colors in terms of the black and white scale. Two basic principles, if constantly observed, will help you in this. *The first,* and the hardest to get used to, *is that any surface in the light, regardless of color, is lighter in value than any surface out of the light.* To prove this to your own satisfaction, hold a piece of black paper under a light, alongside of which is a piece of white paper in the shadow. *The second principle* is that every pure color has a relative value on the black and white scale. Dark blue, for instance, is near black, while lemon yellow is near white. Thus, the lighter the color of the object, the lighter the shadows. *In all cases, however, the first principle still applies.* The best way to learn the black and white values of pure colors is to make a scale of ten values from black to white, and compare various swatches of color with it by squinting your eyes.

THE SLANTED PLANE

adding an extra value in the light,
called a quarter tone

If every object you draw were either round or square, shading it would be quite simple. The varying shapes of most objects is the result of the joining of upright and level planes with tilted or slanted planes. Because slanted planes are at a different angle to the source of light from either upright or level ones, you need an extra value in the light to represent this, and for simplicity call this a Quarter Tone. When such planes are parallel to the light rays, or turned away from them, they take the same values as upright or level ones as shown on the preceding pages on the three-value scale.

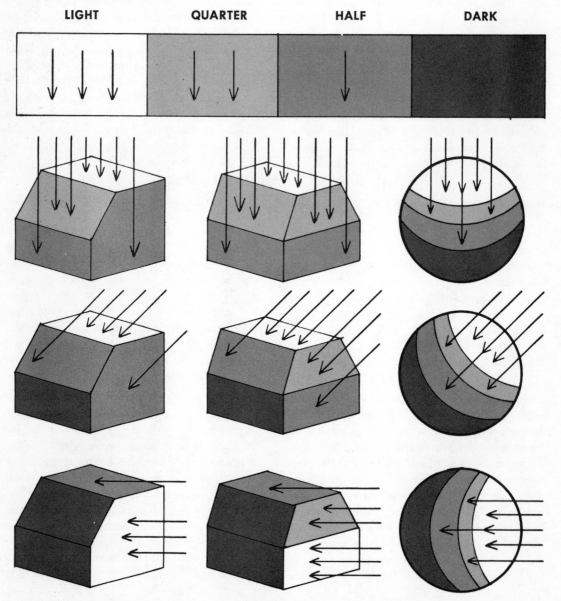

SLANTED PLANES IN THE LIGHT

Any plane, whether slanted, upright, or level, reflects light in direct relation to the direction of the light source. At right angles to it, or nearly so, it will get maximum light. As the plane tilts away from the right angle, it receives less and less light. *But any plane in the light is always lighter than any plane out of the light.* For indicating quarter tones, use your lightest-colored chalk—raw sienna or yellow ochre. A light-colored surface as a quarter tone will be lighter in value than the color of your chalk. To get this lighter value, put white to the paper first, then add the color to it. Remember not to model the lighter planes until the pattern of the darks has been established.

SLANTED PLANES IN THE DARKS

As you see in the photograph at lowest right, a slanted plane turned away from the light source is in the pattern of the darks and therefore can never be as light as a quarter tone. Compare this photo with the one top left. In the latter, one slanted roof top is entirely in the light, the other only partly so. This is because the planes of each roof are at different angles to the direction of light. *When shading a drawing, never forget the direction of the light source.*

QUARTER TONES ON ROUND FORMS

In the diagrams on the opposite page you can see that the nature of any round form automatically prescribes the existence of a quarter tone between the lightest part and the darks. The diagrams cannot show the light coming from in front of the sphere. Since your subjects are usually lighted from in front, a quarter tone will necessarily appear also on the far edge of the lighted surface since this edge is also slanted away from the light.

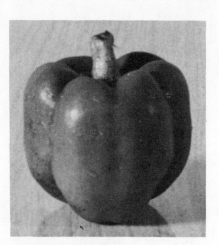

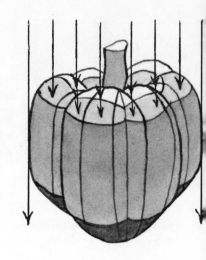

**The direction of the light from the source
changes the patterns of the darks.**

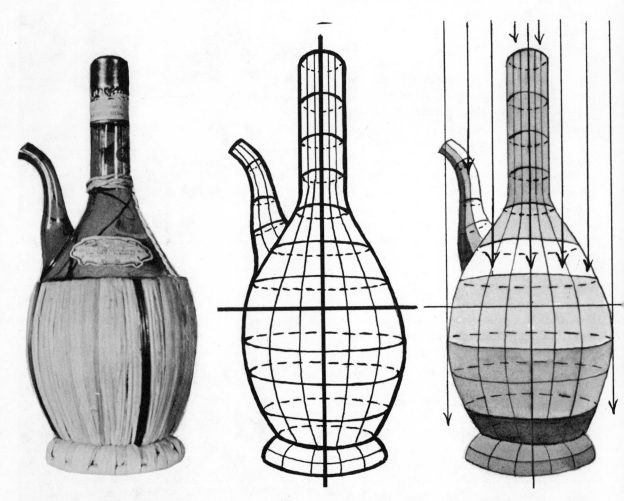

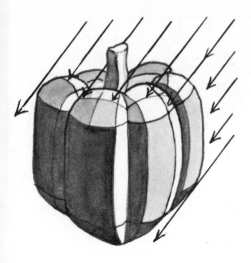

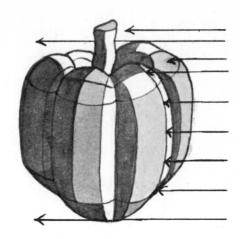

When adding tone to your drawings show only one source of light.

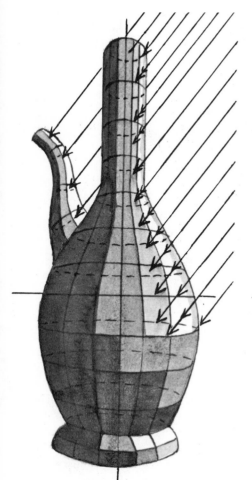

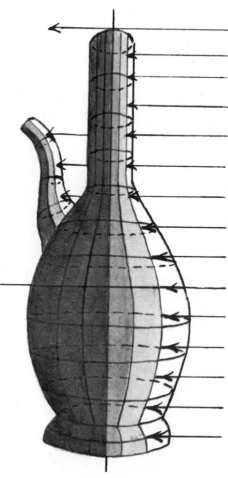

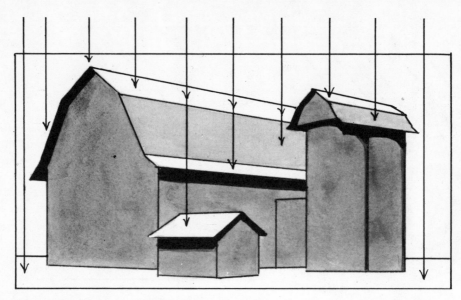

OVERHEAD LIGHTING EMPHASIZES BULK OR MASS

Because all vertical or nearly vertical planes are halftones when lighted from overhead, definition of form is at a minimum due to lack of contrast between light and dark patterns. In its place, however, is the massing of the forms to create a silhouette of great strength and bulk. This, of course, is true for outdoor subjects under sunlight. Under arti-ficial light, the effect would be similar to side lighting, as below. Use overhead lighting when your subject is more impressive as a whole shape or mass rather than in detail. Notice that under this lighting the level ground plane gets all the light since it is at right angles to the direction of light from the source.

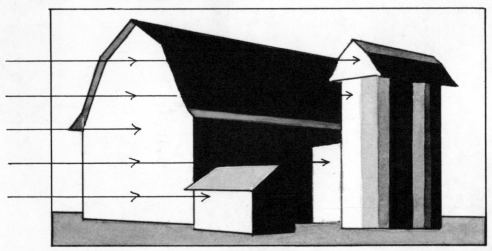

SIDE LIGHTING GIVES DRAMATIC CONTRAST AND DESIGN

In contrast to overhead lighting, just the opposite effect is produced by side lighting. Here we have very few halftones, and instead, strong lights and darks on the large planes. While more detail is visible here than in overhead lighting, it is still subordinated to the design effect. The strong contrast between lights and darks creates a dramatic pattern on almost any subject. For this reason, use this lighting when the design feeling or great drama is more important than maximum definition of form. It is useful also when the detail to be emphasized is only a small part of the whole picture, such as the eyes or features in a portrait, or the center of interest in any picture.

LIGHTING FOR EFFECT

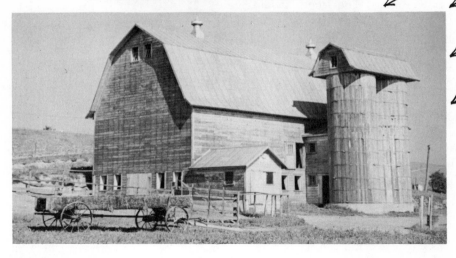

Any subject can be pictured in a variety of ways by changing the direction of the light from the source. Each kind of lighting produces a different effect from the same subject. Normally, most subjects are toned in relation to 45-degree angle lighting; such lighting gives maximum definition of form because of an even balance between light, halftone, and dark. Sometimes, however, such definition may be less important than some other effect. Many times a little patience in waiting to observe a landscape as the sun moves across it will yield the best light for the effect you want. Similarly, indoors, shift the subject in relation to the light source. Don't forget, when working outdoors, that the sun keeps moving, but your picture should show a specific time of day, as well as the kind of day.

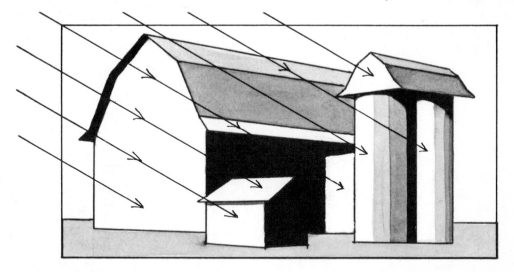

45-DEGREE ANGLE LIGHTING GIVES GREATEST FORM DEFINITION

This kind of lighting is always used when clarity of form is of primary importance. As you see in the photograph of the subject, and in the illustration above, there is an even balance between lighted and unlighted surfaces; that is, between light, halftone, and dark. But notice that the over-all pattern of this balance is more interesting as a composition when the angle of light comes from the left side, as in the illustration, than from the right, as in the photo above. The darkest dark near the center of the picture serves as an anchor to hold the picture together. When working indoors, under artificial light, there is usually more than one source of light. Paint your picture showing only one source.

To tone a drawing, use the side of the chalk, not the ends or corners. The length should be an inch or less. Apply it evenly to the paper, starting always from the darker side. By lifting the chalk gradually off the paper, a gradation of tones results, leading into the lights. In applying the chalk (or paint) to establish values, work across the form, rather than follow the direction of the outlines. This serves two purposes: to separate tones from construction, and to show the planes. If you follow the outlines when toning, you are still *drawing* with the chalk or paint, and the result is what is known as a rendering, or colored drawing. By toning across the form, you are painting, as opposed to constructing or drawing. Only when the subject is completely toned should you draw the final outlines (where needed) to accent an edge or shape.

Once you apply chalk as tone, you will find the construction lines disappearing under it. For this reason, your construction drawing should be quite crisp and strong. Even so, under heavier toning, when the lines fade out, reconstruct once again, if necessary, to re-establish the solidity of the forms. Then add the finishing touches. Because each stage in the development of a painting should be complete in itself, you must think always in the biggest sense of the nature of each step.

The first step in toning, as shown on later pages, is to establish the pattern of the darks. In the big sense, then, this pattern does not consist of patches of darks on the objects and patches of shadow behind them. The pattern is what you see when you close your eyes to a squint. Seen this way, the outlines of the objects almost disappear, leaving only masses of dark and light. It is the whole mass of the darks that you establish first, to include both shadows on the objects and darks in both foreground and background. This first step can be done lightly to set it up, then worked into for actual existing tones or values.

The chalks you are working with represent five values from white to black. By mixing one with another you can get the intermediate tones. With a little experimenting you will be able to get many different color effects with just these few chalks. For instance, black or umber and sienna give a greenish color, red and white a pink, red and sienna an orange, black and white a cold gray, umber and white a warm gray. You should not use full color until you have learned to see color in monotone, related to the black and white scale.

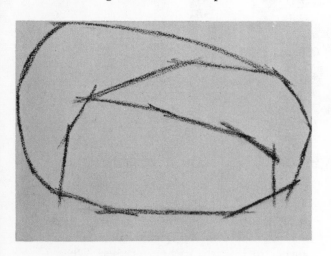

1. To learn to use white as a color, start your drawing on tinted charcoal or pastel paper.

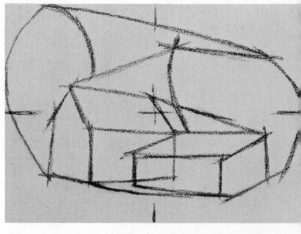

2. For drawing the envelope, and the envelopes within envelopes, start with the lightest color chalk.

TONING THE DRAWING

using four values and white to complete the picture using chalks or paint.

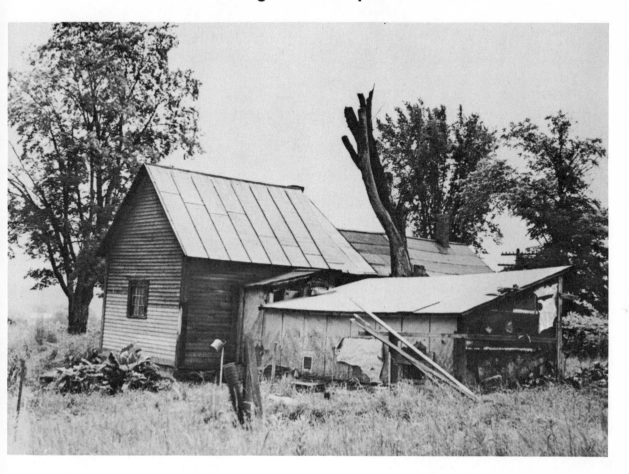

Construction drawing shows the basic shapes, not minor detail.

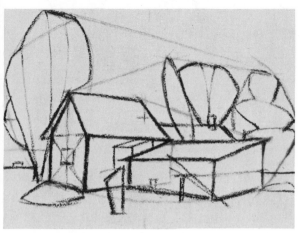

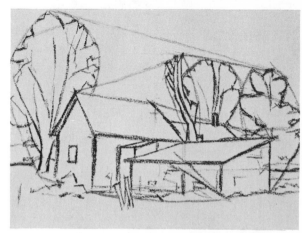

3. Check shapes and sizes with one another, then indicate them with red chalk, the next darker color.

4. Still with the red chalk, develop the shapes as masses rather than in contour or outline.

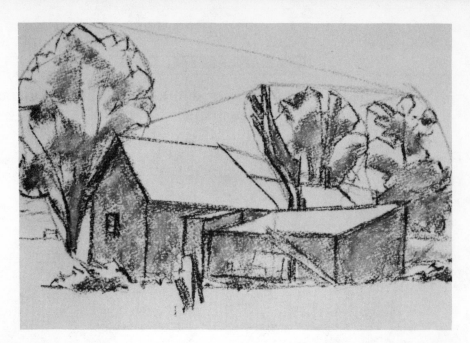

Step 1
The
pattern
of the
darks.

After strengthening the construction of all solid shapes with the dark brown chalk, *make note of the direction of light from the source.* Squint your eyes at the subject until you see the darks as masses, not patches. The pattern of the darks is made up of all the surfaces and areas which are out of the light.

When working outdoors in sunlight, the picture must be completed in relation to the first pattern established, to show a specific time of day. For a very light-colored subject this pattern might be indicated with light chalk, but usually a halftone value is more suitable, made with the red chalk, applied lightly.

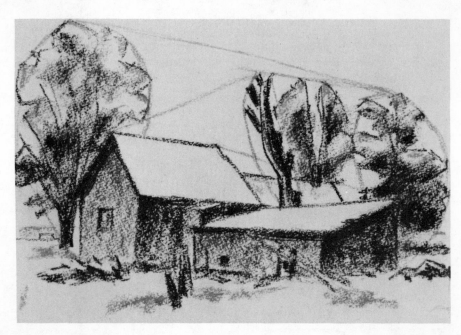

Step 2
Add
the
darkest
darks.

To add more feeling of depth, find the darkest areas on the subject and indicate them first by bearing down heavier with the red (or halftone value) chalk, then adding some of the darkest or umber chalk. When adding the darkest darks to the pattern start always with the very lowest values visible on the subject, then work out from them until you reach the lightest

values to be seen on any surfaces not in the light. Now notice that even on a tinted paper, without touching any surfaces in the light, the broadly stated pattern of the darks has added a third dimension to the subject—depth. How dark this pattern should be is determined by the nature of the subject.

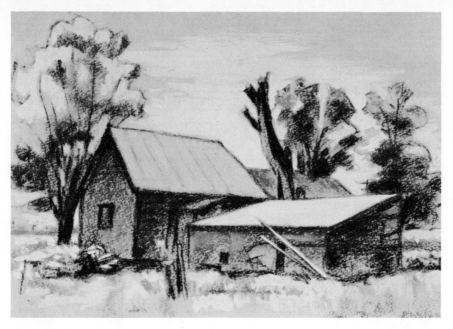

Step 3 Add values in the lights.

To indicate the lights, reverse the order by working down from the lightest (or white) areas through the quarter tones into the half-tones. Again, by noting the direction of the light from the source, paint in those planes or areas that are at right angles to it, or nearly so. These are getting all the light and will be almost white, depending on the color of the objects. Put them in with white chalk first, to be moderated later. Next find the slanted planes in the light, which will be quarter tones, and use the sienna chalk moderated with white. All these toning steps can be done with grays of various values, but the colored chalks of like values make it easier to keep values separated.

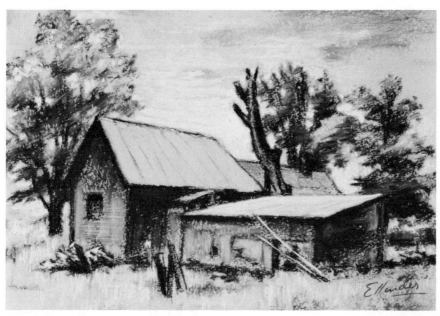

Step 4 Add detail and texture.

Although you have black chalk as your lowest value, use it very sparingly. In nature there is black only where there is no light at all, so that black to us is a color like any other. Use it mixed with white or another color for grays, or for accents in the darkest areas. In painting with a full-color palette it is best not to use black at all, relying instead on umbers.

When all the areas and surfaces have been indicated as to their value relative to the direction of light, in the big sense, then, and only then, should you add texture and detail. *Your finished picture should represent the subject as it looks to you at a glance, and not in minute detail, as in a photograph.*

first: the pattern of the darks, then the darkest darks

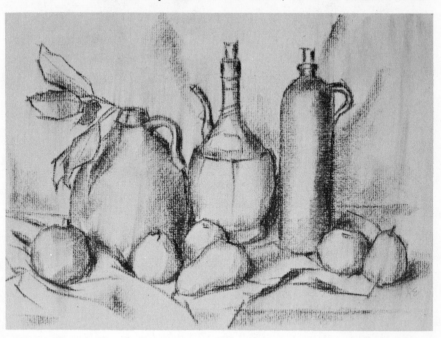

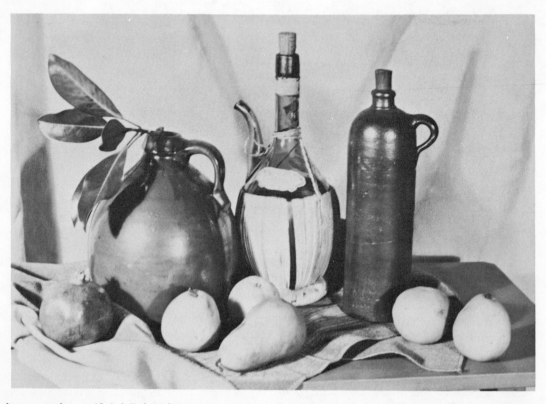

Indoors, under artificial light, there are usually several sources of light illuminating the subject. Your picture, however, should be toned to show only one source, as though in daylight.

Whatever the color of the object, the planes receiving all the light are lighter in value than any planes entirely out of the light.

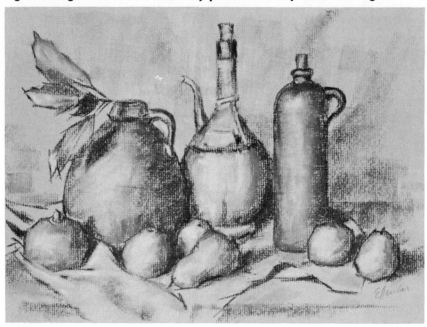

final step: strengthen construction and blend the tones together

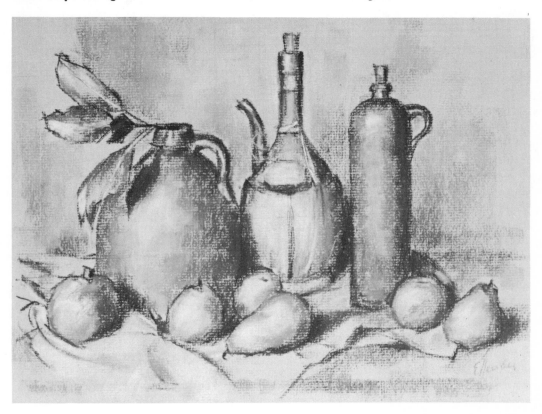

DRAWING THE FIGURE

With few exceptions, almost everyone learning to draw hopes to be able to represent the human figure, and eventually to be able to do a portrait. To do this competently requires considerable study of the anatomy of the body and familiarity with the elementary principles of solid form in perspective. For the latter reason, you should study the section on Scientific Perspective, which follows —in particular the circle and the cylinder. As for anatomy, there are many books available to help you, of which two are highly recommended: *An Atlas of Anatomy for Artists,* by Fritz Schider, and *Life Drawing and Constructive Anatomy,* by George Bridgman.

If you have ever attended a life sketch class you undoubtedly noticed that most of the students concentrate on trying to capture the outline of the figure (Contour Drawing), usually with indifferent results. If it is difficult to draw a Dresden pitcher correctly as an outline drawing, without preliminary sketching, then the complicated structure of the human figure, which is many times more involved, presents the supreme challenge. Just as drawing outlines of simple objects provides no real understanding of the true basic nature of the forms and their relation to one another, so *drawing contour of the figure, for beginners, will at best produce only superficial skill,* and at that, for only a limited few.

For this reason you are urged to apply the principles of visualization (outlined in previous chapters), which you have learned in this Basic Drawing method. When properly applied, in the sequence prescribed, the figure ceases to be a strange problem. Rather it becomes a vastly more interesting one, and in many cases, particularly action poses, easier to draw than groups of objects. The stages of development are the same: the Envelope enclosing the entire figure, the Biggest Shape and Next Biggest Shape in the Envelope, the Rhythm or X-ray lines connecting from side to side and top to bottom, and finally the Construction Drawing.

To see the figure and represent it in a drawing, you will profit from a single pose for at least three hours, and work on a large pad or sheet of paper (18″ or 19″×24″). This will give you time to check each stage for proportion and relationship of the parts. After locating the parts of the figure within the envelope, you should try to draw the head, chest, and pelvis as solid geometric forms even though only the sides may actually be visible. This will help you later when you know enough anatomy to be able to draw or construct a figure from memory, or to correctly place the small forms such as features or muscles on the surfaces of the basic geometric shapes.

If you sketch short poses, whether in sketch class or on the beach, concentrate on finding the rhythm and action lines, and the basic shapes within them. When these lines are drawn freely and with spirit you can capture the essentials of the body in movement, and in time be able to construct the figure in detail within them. Even professional models cannot hold a truly active pose for more than a few minutes. Therefore it is essential that you capture the important visualizing lines in just a few strokes. Even seated or reclining figures on the beach always seem to change position as soon as you start to draw. There just isn't time to do an outline drawing of candid poses, until you are truly expert. The more rhythm drawing you do, the quicker you will train your eye to see the figure as a whole.

Unlike drawing most single objects with many like parts, such as a spray of leaves, the human figure has parts of different shapes and sizes. In this sense, then, it may be considered as a group of objects, held together by the spine and the muscles. For the study of the muscles, wait until you can assemble the parts correctly. To help you do this, the following pages are designed to show you the basic major portions of the figure reduced to their simplest geometric shapes. Remember that even when drawing smaller portions of the figure such as the hand or foot, enclose each first in an envelope and then draw the biggest and next biggest shape within it. Always work from the whole down to the small parts, to learn to see big.

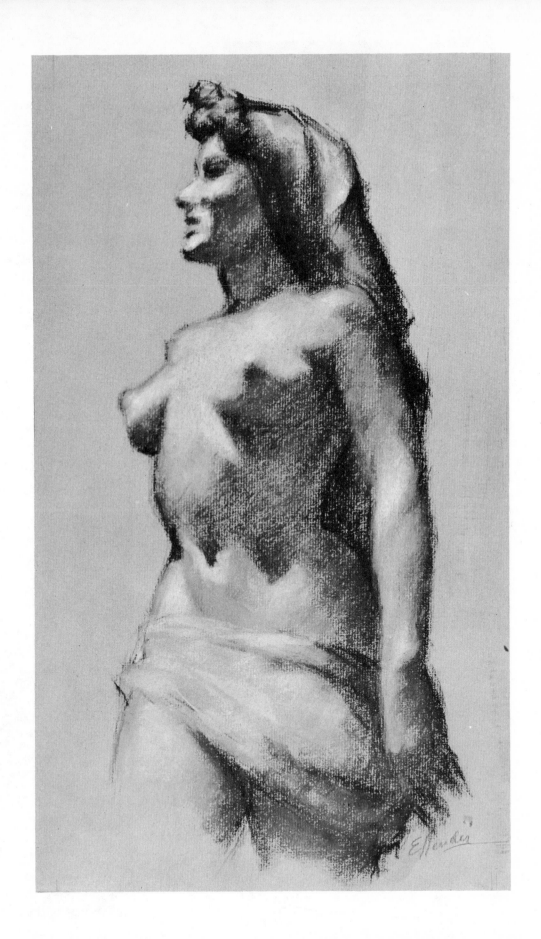

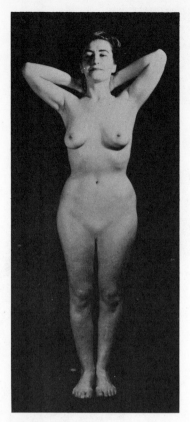

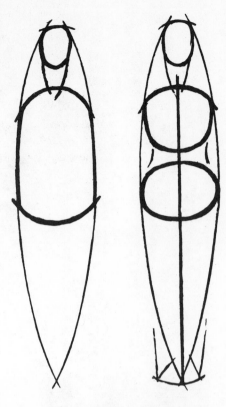

The Biggest and Next Biggest Shapes within the Envelope:

THE ENVELOPE: When drawing the envelope to enclose the whole standing figure, consider the arms and the feet as variable factors to be added later. Starting with the head, connect it with the edges of the shoulders, and then, touching the extreme outermost parts and/or points of the figure, extend the envelope to the ankles.

THE BIGGEST SHAPE: Usually this is made up of the head and torso together. In front view of the figure, consider the base of the torso as a curved line across the crotch. In back view, it is somewhat lower, marked by the lower line of the buttocks. In profile or three-quarter view, both defining points are visible, giving a rounder curve. After finding the base of the torso in relation to the whole figure, mark off its upper shape at the shoulder line, then the oval for the head.

THE NEXT BIGGEST SHAPES: Within the torso as a whole are the rounded shapes of the chest and pelvis. As basic shapes they are connected only by muscles, which are added later. They are different in size and form in men and women. Men's chests are rounder, and pelvis areas narrower than women's. The base of the chest is usually

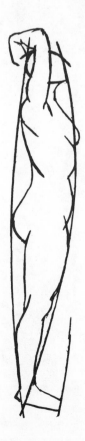

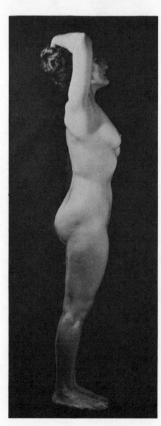

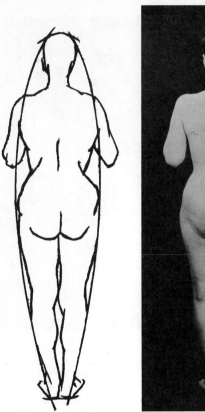
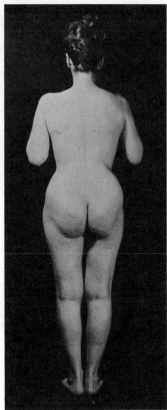
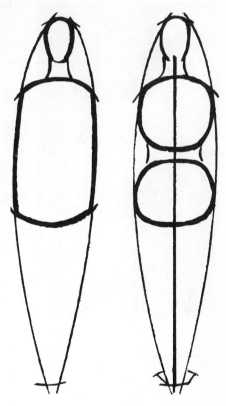

1. the head and torso
2. the torso—chest and pelvis

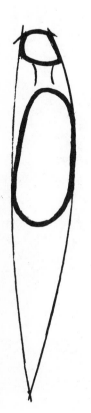

visible as the rib cage. For the top of the pelvis, draw a line across the hips.

AIDS TO DRAWING: When you have drawn the basic shapes within the envelope you will find it most helpful to draw the mastoid muscles of the neck, from behind the ear to the hollow in the center of the clavicle, or collar bone. From this point, draw a vertical line downward. In a standing figure this line represents the center of balance, and helps to locate the position of the feet in relation to the head. Also, since it is a vertical line directly related to a point on the figure, it is more useful as a measuring line than the center line in a rectangle enclosing the envelope. After you have drawn this vertical line, notice whether the envelope to the ankles is correct. In the profile figure at left, the vertical line shows that the toes are on it, but the ankles are further back.

Just as in the first steps in drawing objects, make these visualizing lines with your lightest-colored chalk, and draw lightly with a clean sharp line. The diagrams show the shapes in heavy lines for clarity. Remember not to proceed further until you have checked the proportions of each shape in relation to the whole, and to each other.

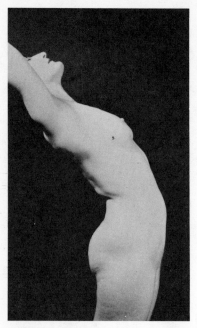
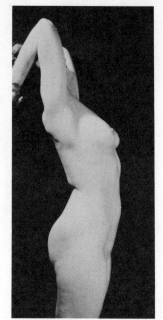
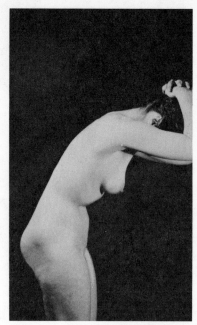

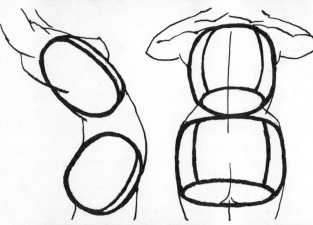
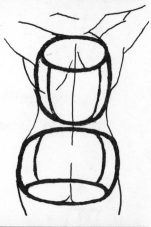

**BENDING
AND
TURNING
OF
CHEST AND
PELVIS**

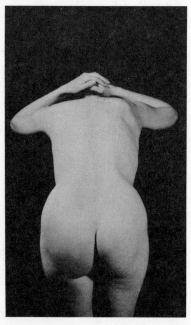
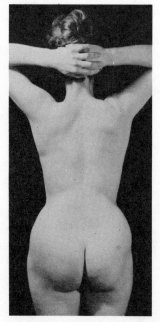
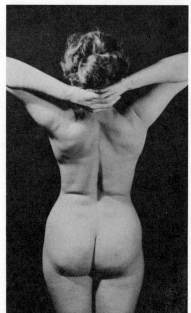

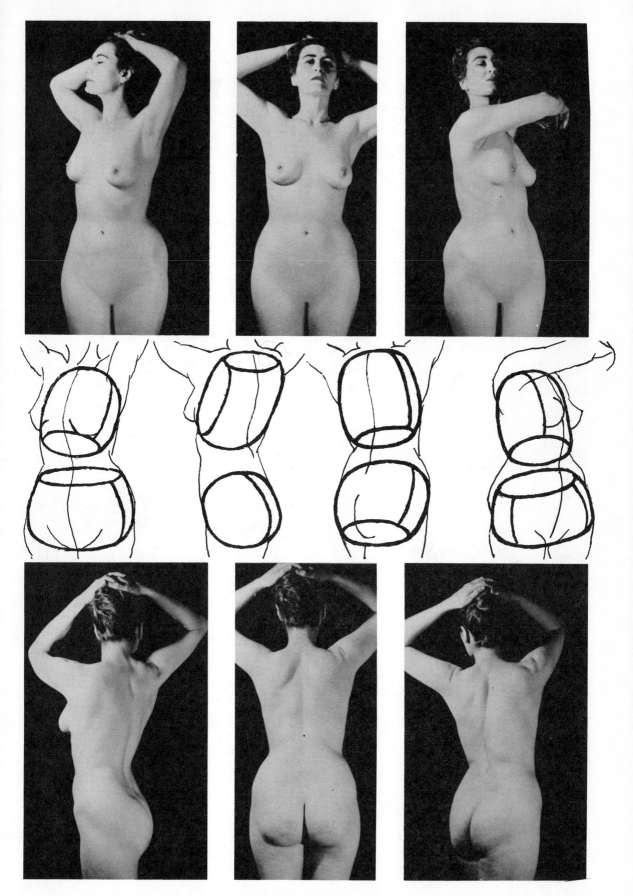

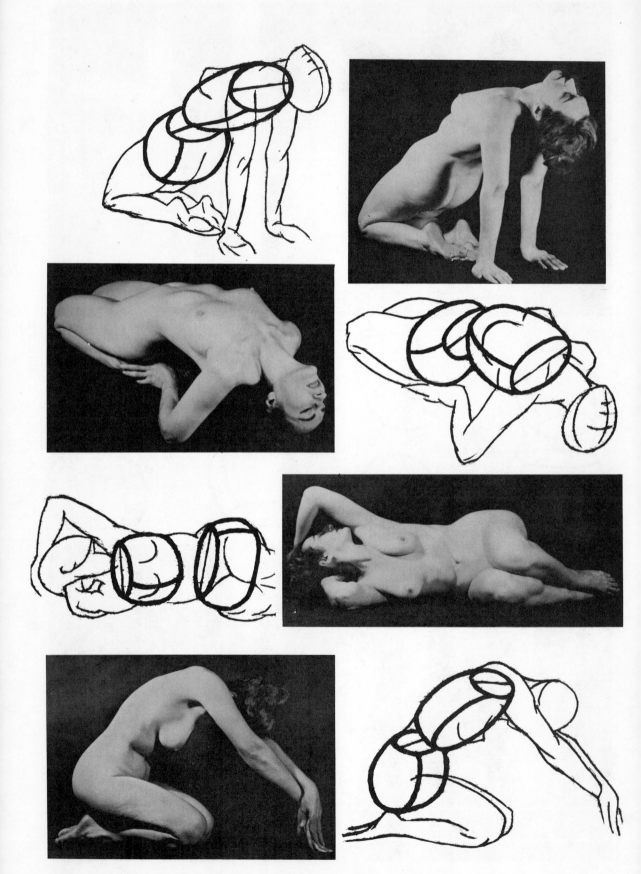

THE TORSO IN PERSPECTIVE

In the chapter on The Nature of Solid Form you learned that a straight-sided solid was the basic structure for building other solid shapes. Illustrated below, the diagram shows how the center lines on the straight-sided shapes help to give the diameters of the rounded shapes.

On the page opposite you can see that *the long diameters of the ellipses at the top of the chest and pelvis give the angle or tilt* of each. For the chest, find the line across the shoulders; for the pelvis, the line across the hips. These lines we call the Action Lines, and how we use them is described on the next pages.

You may be satisfied with drawing only the outlines of the chest and pelvis. But for a thorough understanding of the planes, indicate also the sides of each form whenever you can, to help you later when toning.

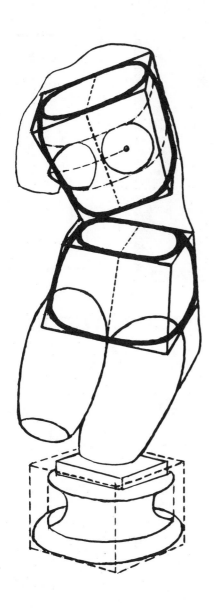

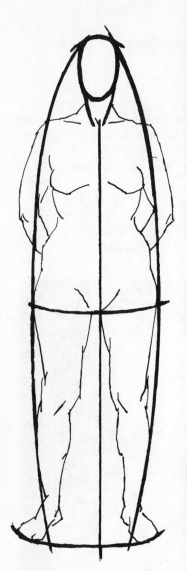
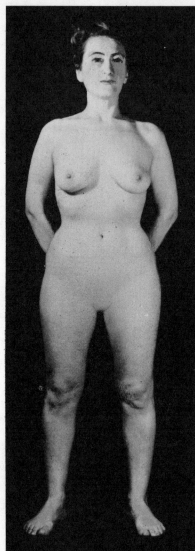
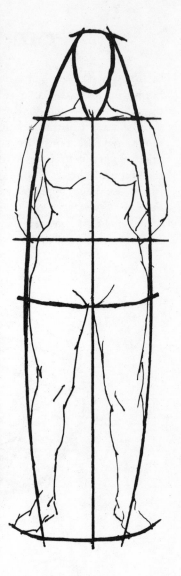

THE ACTION LINES—UPRIGHT FIGURE

When an upright figure is balanced evenly on both feet, whether at attention or at rest, the center of balance is between them. To show this, as you already know, draw a vertical line down from the center of the collar bone. In this position, the lines across the shoulders and the hips are at right angles to the vertical balance line. Using these lines as diameters for ellipses, the rounded shapes of the chest and torso are easy to draw because they are in parallel perspective.

In most cases, however, a standing figure

is usually bearing the weight on one leg. This raises the hip side of that leg, while lowering the other. As counterbalance, the opposite shoulder rises. As a result, the lines across the shoulders and the hips are now at angles to the center of balance line, which now meets the center of the foot bearing the weight.

To draw such a standing figure, the quickest way to find the shapes of chest and pelvis within the envelope is, therefore, as follows: 1. Draw the envelope (from head

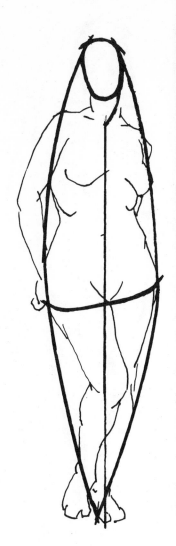
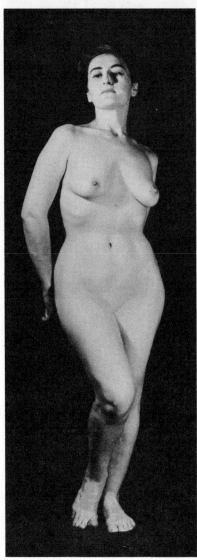
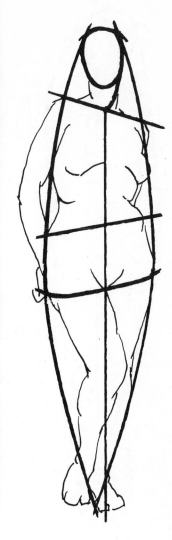

to shoulders, to pelvis, to ankles), and check it for proportion of width to height. 2. Within it mark off the depth of the torso, at the crotch in front view. 3. Draw an oval for the shape of the skull. 4. Draw the neck muscle from behind the ear to the center of the collar bone. 5. Drop a vertical line down from this point; the foot bearing the weight will be on this line. 6. Draw the action line of the shoulders across the base of the neck. 7. Locate the hip bones (which are at the top of the pelvis), and draw a line to connect equivalent points.

You now have indicated the diameters of the ellipses forming the tops of the chest and pelvis, and using them as construction lines the whole shapes are easily drawn in relation to them. Remember when drawing the basic shapes of the head, chest, and pelvis that it is *the bone structure* of the figure that you are indicating. The muscles and fat on the body, and the hair on the head, are variable factors, and are added later in doing a construction drawing of the actual figure. Having the basic shapes established first will help you to locate the muscles and features.

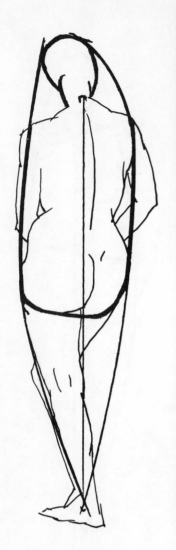
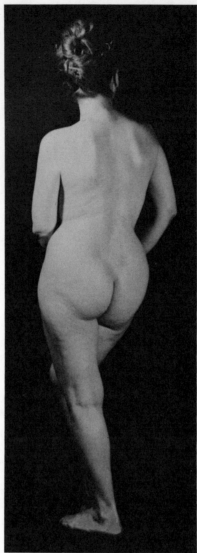
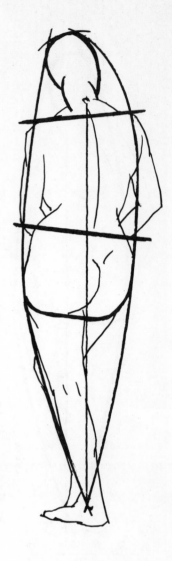

ACTION LINES—BACK VIEW AND IN MOTION

In a back view of an upright figure, the center of balance line is drawn from the first thoracic, or chest, vertebra at the bottom of neck, and, just as in the front view, will meet the ankles of the foot bearing the weight. Across it, draw the action lines of the shoulders and hips, and proceed as before.

Now notice that when the figure is in motion as opposite lower left, the center of balance line falls outside the feet. In such a case its use is mainly to properly place the feet in relation to the head. In other cases of an upright figure not at rest position, the center of balance line will meet the foot bearing the weight, though not necessarily at the ankles, or fall between the feet.

In drawing the action lines bear in mind

the following points. The shoulders are considered as ending at the outside ends of the scapulae, or shoulder blades, not the muscles overlapping them. The action line of the hips connects the topmost points of the pelvic girdle that you can see from *in front*—known as the anterior superior iliac spine—and is *higher in back* because there it connects the uppermost points of the ilium, or rear of the pelvis. Do not confuse these points with the waistline, which is always above them.

When the chest and pelvis are rotating in different directions, as they almost always do when the figure is in action, it necessarily follows that the action lines will not be parallel to one another.

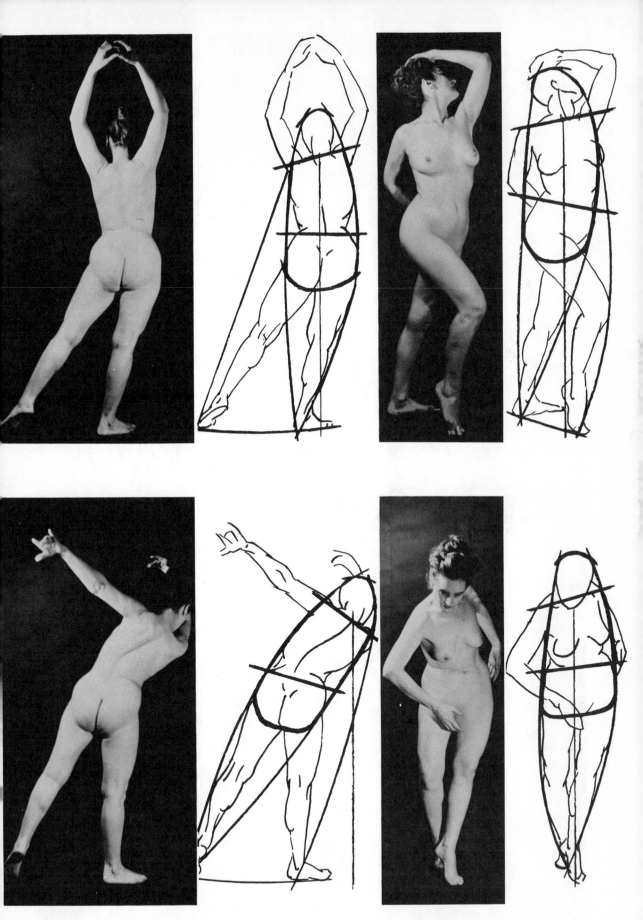

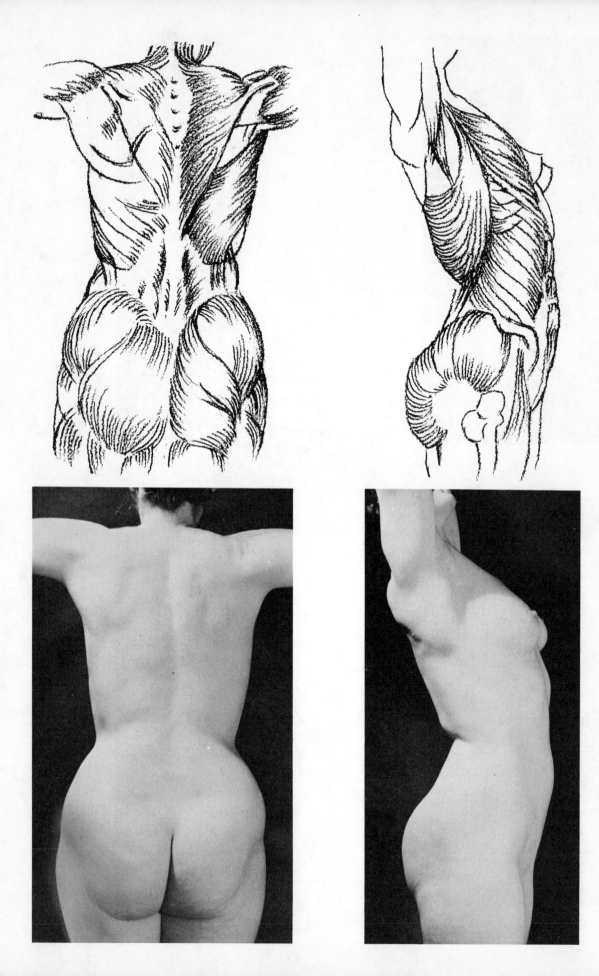

MUSCLES OF THE TORSO

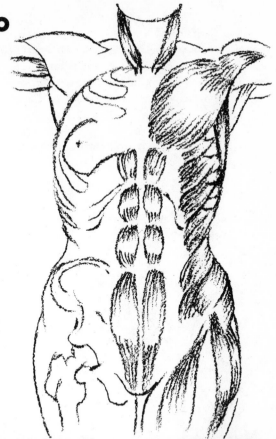

Since our purpose in this book is to learn to see the big things before drawing mere surface characteristics, no attempt is made to include a detailed study of anatomy, which should come later. With the basic knowledge you acquire from practicing the procedures outlined thus far you will be able to draw the human figure as easily as any other subject. But just as with other subjects, your skill and accuracy of vision depend on constant practice and application.

To convey the true nature of any given type of figure requires that you have at least a minimum knowledge of the overlapping of the muscles. Even artists who once knew the names of all the muscles, myself included, forget the names and refer to them by more common names like the neck, shoulder, or back muscles. But the knowledge of where they attach to the skeleton or pass over or under one another is there. On the arms and legs the larger muscles are usually well defined and can easily be identified. On the torso, however, they are not as familiar or too well marked.

FRONT VIEW: The pectoralis major, or breast muscle, attaches from the arm to the sternum or center bone of the rib cage. Overlapping it at the shoulder is the deltoid. All along the sides are the external oblique muscles going around to the back. The abdominal muscles extend from the chest to the groin. Crossing over them are the internal oblique muscles.

BACK VIEW: From the top of the rib cage to mid-spine, crossing the shoulder blades from the shoulder socket, the trapezius muscles form a V. From underneath the armpit all around the lower half of the rib cage, the latissimus dorsi passes under the trapezius. At the sides, from the top of pelvis, or ilium, to the thigh, is the gluteus minimus. And then the one most familiar of all because it shows except when you sit on it, is the buttocks, or gluteus maximus.

SIDE VIEW: All the above muscles are visible where they fasten to the skeleton or pass one another, except the trapezius. In addition, the muscles of the thigh attach to the pelvic girdle—the tensor across the hips, the vastus lateralis across the gluteus maximus in the rear, and the rectus femoris or big thigh muscle in front.

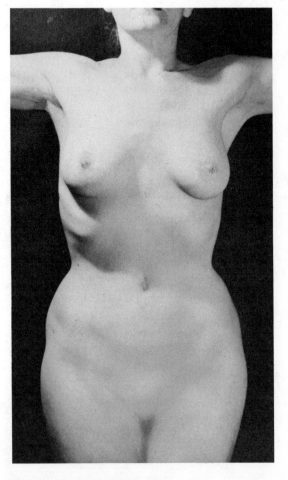

The human figure in graceful action provides endless varieties of fascinating rhythms because its parts move in arcs. As you learned in the section on rhythm, or X-ray lines, such arcs are not visible as lines. Learning to see them helps to relate the sides of shapes to one another across the envelope. In figure drawing, rhythm lines help you to quickly establish key points and shapes with just a few strokes. When the action lines are then indicated, you have all you need to construct a figure within them.

In most action poses, one side of the chest is in rhythmic relation to the inside or outside of the thighs or legs.

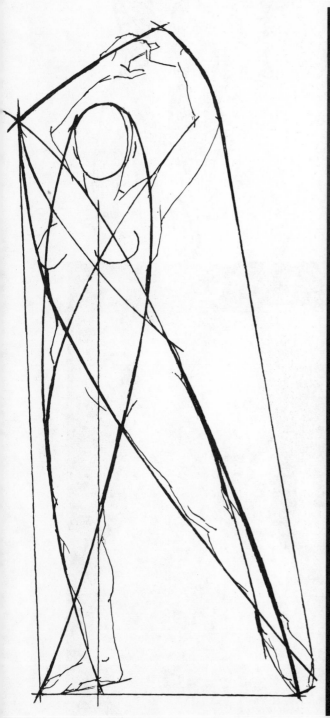
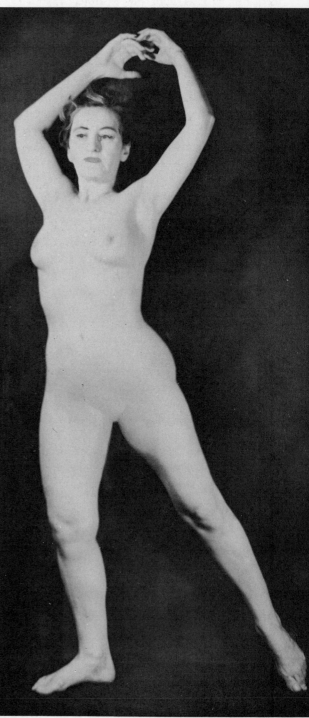

RHYTHM LINES

connecting points and/or shapes with one another

from side to side, top to bottom

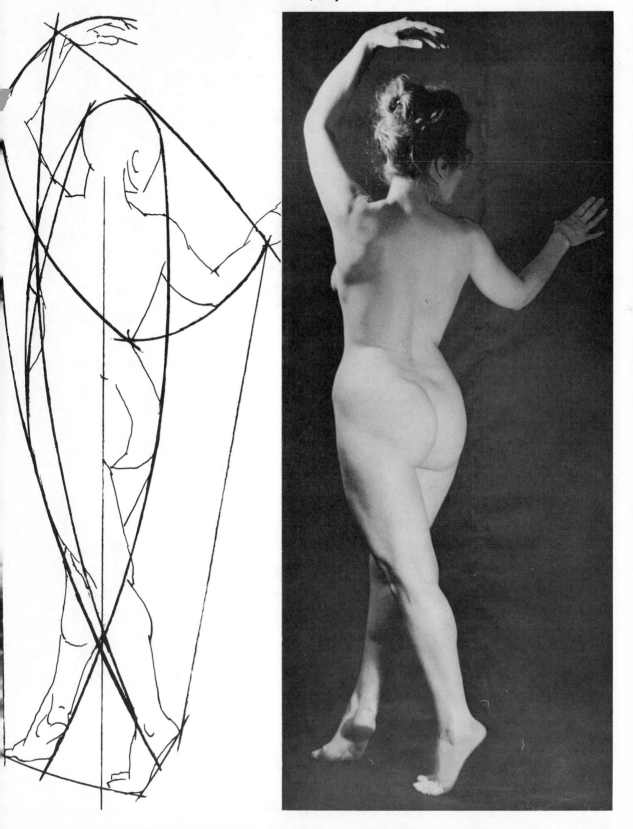

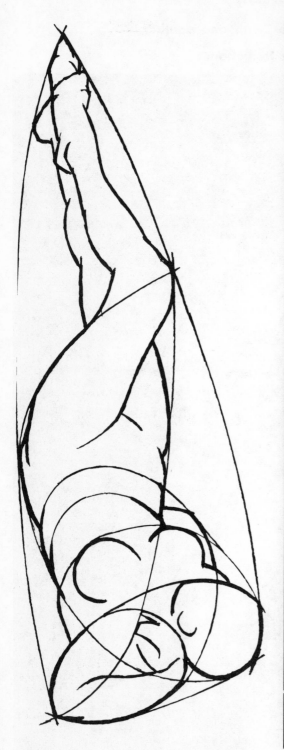

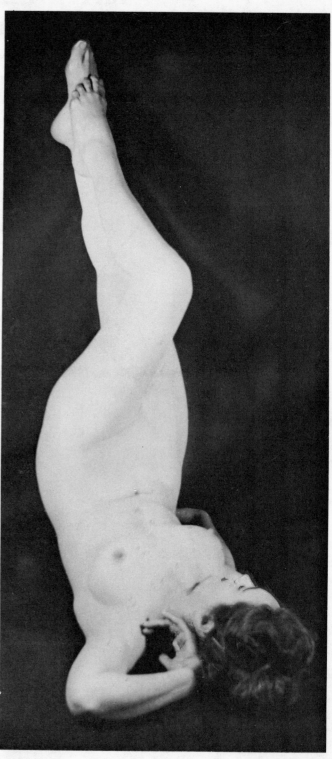

After you have found the rhythm lines to connect the head and the larger body shapes with one another, see how many you can find in smaller areas. In effect, you will then be drawing envelopes within envelopes, just as you did in drawing groups of objects. The more such envelopes you find, the more accurate will be your vision and drawing.

RHYTHM LINES

The longer rhythm lines relate the major portions of the body to one another. But just as in drawing simple objects, you can project any given line until it meets the opposite side of the envelope. In the case of figure drawing, such projected lines will almost always meet some other key point within the figure and so further help you to see any given point, not by itself only, but in relation to the whole figure. Try drawing these rhythm diagrams in large size.

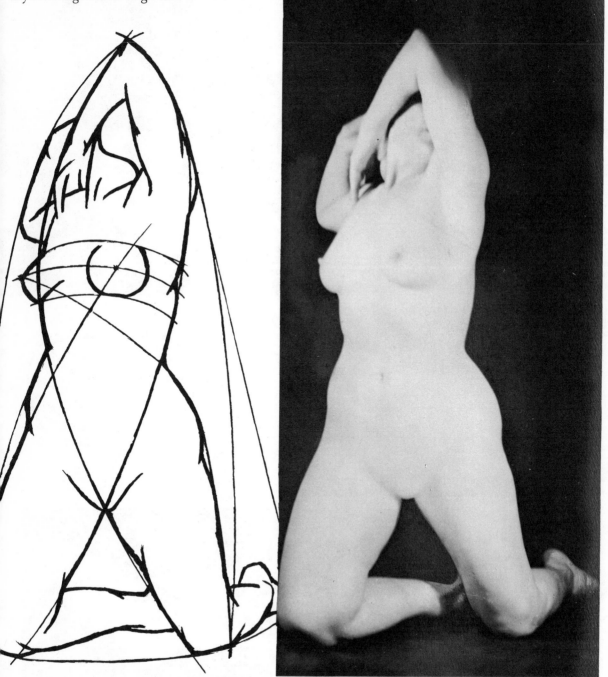

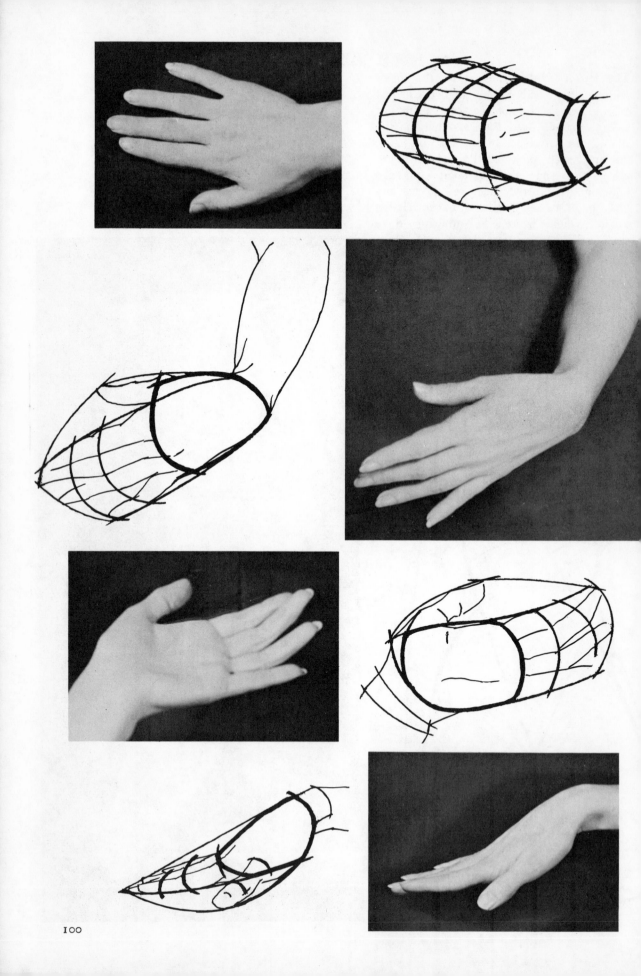

ARMS AND HANDS

As basic shapes, the forearm and upper arm may be imagined as long cylinders tapering toward the ends. The two are related in an arc when extended. The hand has one basic shape, like a wedge, for the palm. To this shape, which moves in arcs from the wrist, are attached the long cylinders of the fingers. The joints of the fingers are related in arcs relative to the knuckles, the middle finger knuckle being the high point of the arc.

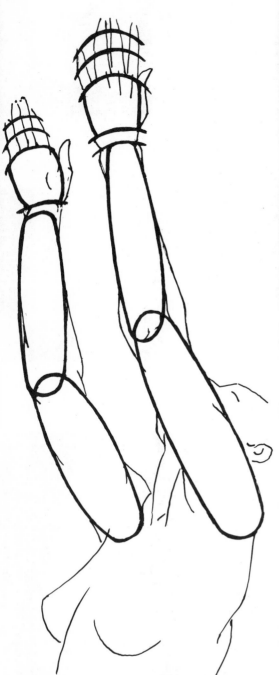

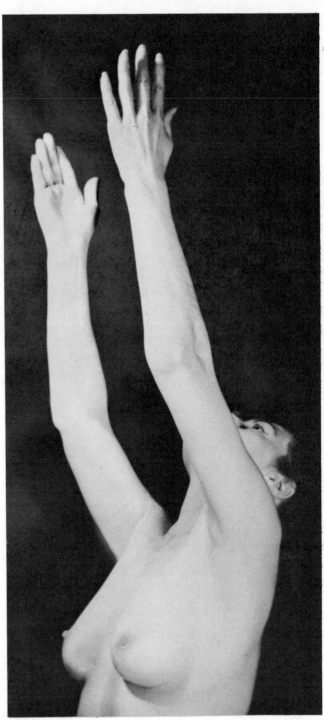

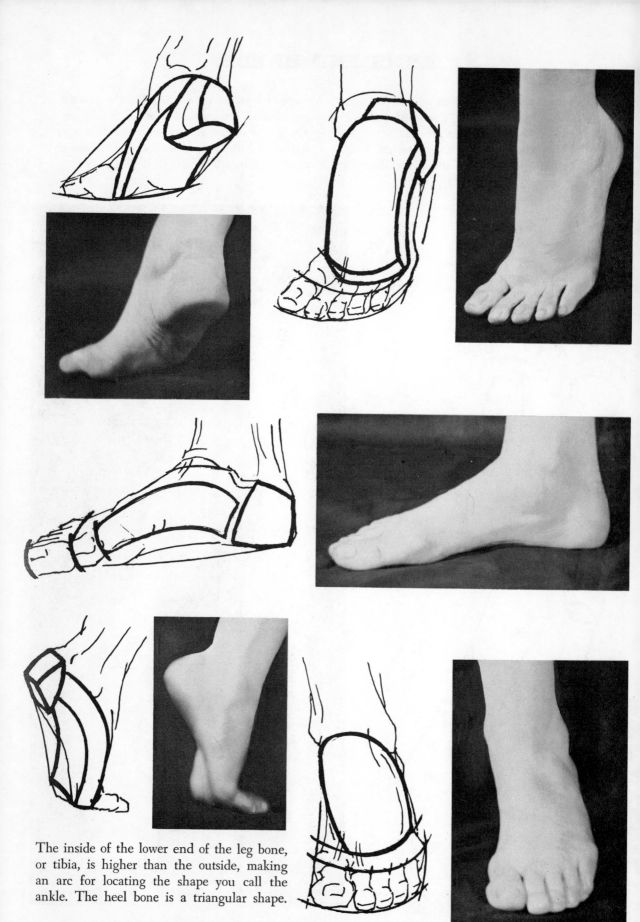

The inside of the lower end of the leg bone, or tibia, is higher than the outside, making an arc for locating the shape you call the ankle. The heel bone is a triangular shape.

THE LEGS AND FEET

The thigh is basically an elliptical shape tapering slightly to the knee. The leg is a more teardrop-shaped ellipse, ending in an arc at the ankles. The knee cap covers the overlapping of the two, from in front. The foot is an arch made of several small bones, the toes in arcs at the front, and the heel, which is wedge-shaped.

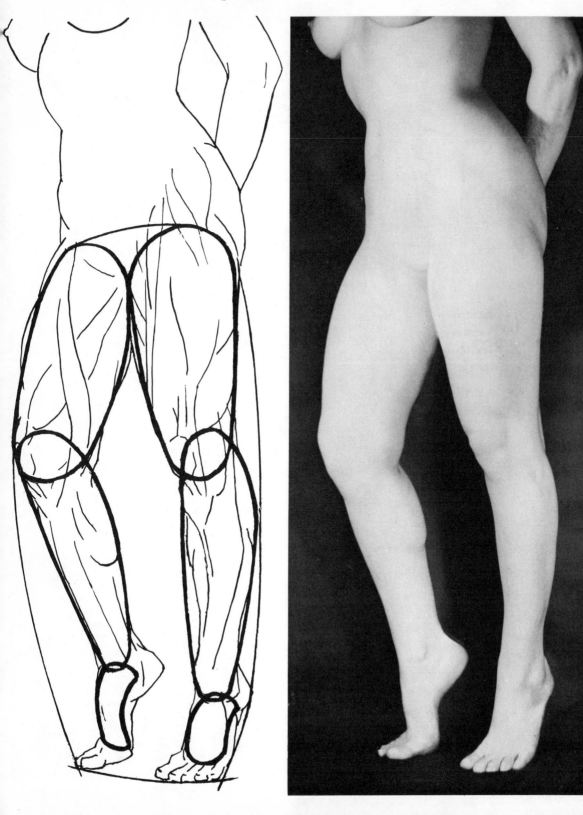

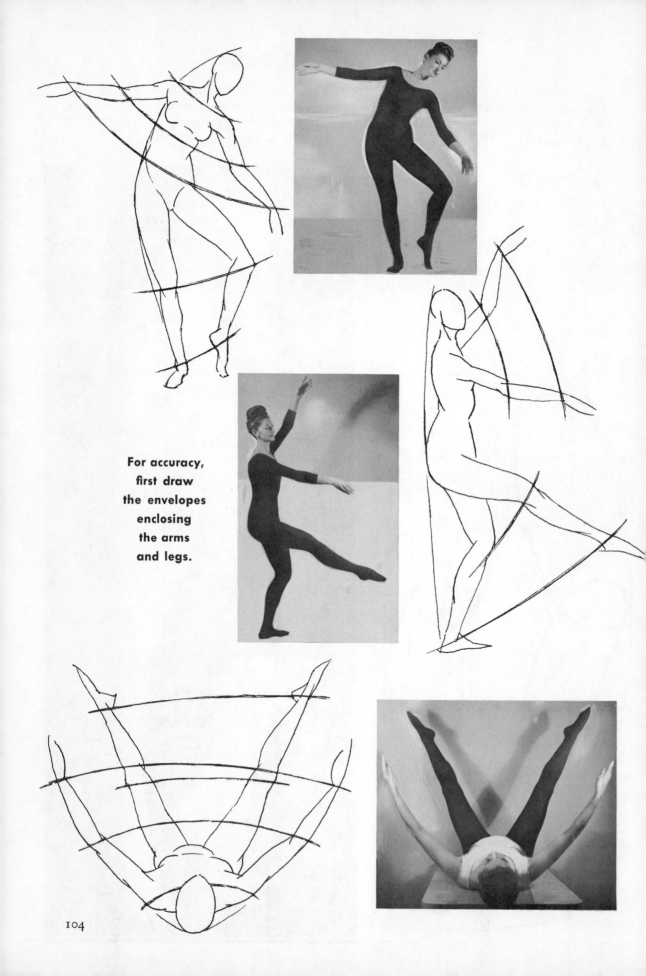

For accuracy, first draw the envelopes enclosing the arms and legs.

THE ARMS AND LEGS IN MOTION

Each moves in an arc
from shoulder and hip.
For correct relationships of the joints,
connect equivalent points in arcs.

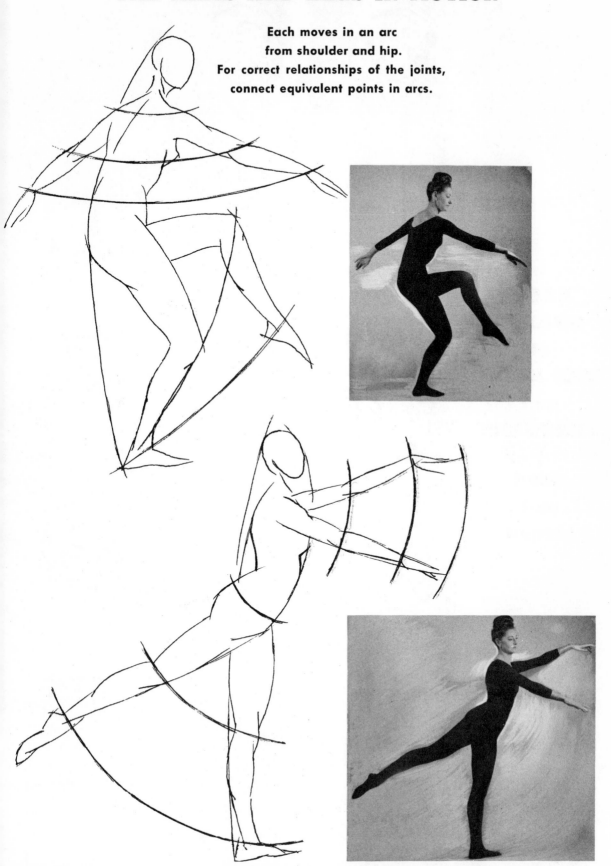

**BASIC
SHAPES
of
THE HEAD
and
FEATURES
·
tilted
and
turned**

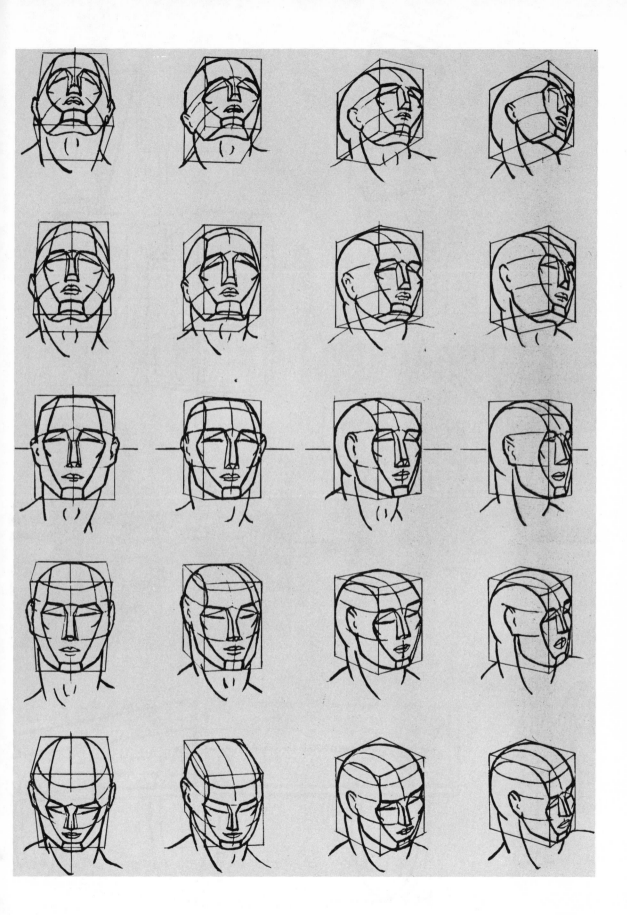

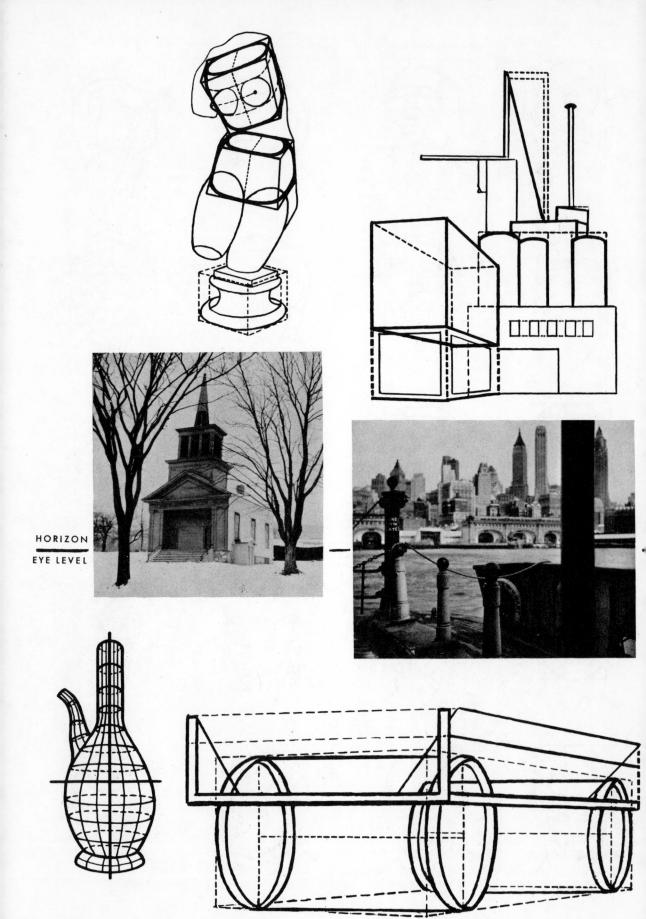

HORIZON
EYE LEVEL

SCIENTIFIC PERSPECTIVE

the science of drawing objects on a flat surface

as they appear to the eye from any given distance or position.

When you use the Basic Drawing method to represent an object or group of objects in a drawing, you are making a statement of the shapes and their relationships to one another as they appear to you from your viewing position. *By definition, then, you are automatically drawing them in "perspective."* Scientific Perspective, however, provides the rules and principles which enable you to represent a subject without actually seeing it. In this respect, more advanced study than is given here is needed for use in fields such as architecture, engineering, industrial design, isometric drawing, etc. Many books are available covering its use in these fields. In the following pages are the basic principles of elementary knowledge of the subject, which will suffice for average use. When you understand them, you will see planes and shapes more accurately, and will also be able to correct a first statement scientifically.

The word "perspective" is derived from the latin word *perspicere,* meaning "to see through," and accounts for the use of the term *the picture plane.* Any given subject actually exists in three dimensions, but if you transcribe it onto a sheet of tracing paper placed on a window pane, your drawing represents the subject on a two-dimensional, or flat, surface and is therefore in "plane" perspective. Where you place this picture plane in relation to your viewing position will therefore determine the sizes and shapes of the subject.

To properly describe a subject on the picture plane you will use various terms of reference. Their meanings follow, in relation to the *station point,* which indicates the position of the viewer. As you shift the station point the appearance of the objects changes, as in a classroom where each student sees the same objects from different station points.

THE GROUND PLANE: Outdoors, refers to the surface of the earth extending as a flat plane as far as the horizon. Indoors, its equivalent is the floor plane, which of course is bounded by its walls.

THE HORIZON OR EYE LEVEL: The level or horizontal line representing the meeting of the sky and earth, and always equivalent to the eye level of the viewer at his station point. Outdoors, where sky and earth do not meet visually, it is located at the line where water or the ground plane meets a slanted or vertical plane—shown on the photos opposite. Indoors, of course, there is no horizon in the true sense. In its place only "eye level" is appropriate, and is imagined as the far edge of a horizontal plane level with the eyes of the viewer at his station point.

THE LINE OF SIGHT: Also known as the *center ray of vision,* it can be imagined as a line drawn through the sights on a rifle, between your eyes and the target, and beyond. As such, then, this line will rotate like the radius of a circle as you move your head. The point where this line of sight strikes the object is the *focal point* or *point of sight.* In most drawings the point of sight is directly in front of the viewer, and can only be represented in a diagram as a vertical line at right angles to eye level. The shapes of objects change their appearance in direct relation to their location in space relative to their distance away from the center of vision.

THE VANISHING POINTS: The point or points where lines that we know to be parallel seem to converge on the horizon or eye level. It is this optical distortion from reality which enables us to judge distance, and to so represent it. Most familiar, of course, is the meeting of the two sides of a road at a point in the distance on the horizon. Most often the vanishing points you will require are located on the horizontal plane, defined by the horizon or eye level. Occasionally, however, the *line of sight* is rotating through a vertical plane. In such a case it may be regarded as a vertical-plane equivalent of eye level, and will be the line on which parallel lines seem to converge. The need for this line appears in three-point perspective and in reflections. Planes change their shapes as they recede from the center of vision.

LINE OF SIGHT

HORIZON

(EYE LEVEL)

Parallel lines converging at intersection of line of sight and horizon.

HORIZON

(EYE LEVEL)

Parallel lines converging on the horizon at an angle to the line of sight.

ONE-POINT (or parallel) PERSPECTIVE

Parallel lines receding toward the horizon or eye level converge at a vanishing point upon it.

This is the principle on which is based all drawing of planes in perspective. As described in the section on the nature of solid form, any geometric body can be constructed within the boundaries of a rectangular solid. Therefore, once you can represent such a body in any position or distance, all others may be constructed in relation to it.

Usually, when referring to parallel lines going away from the station point of the viewer, you think of railroad tracks or the curbstones on a street or road. They appear to converge at a point on the horizon, and as such they exist on the ground plane, the sides of which are not defined. But where the planes are much smaller, revealing the sides (as in the station platform and roof in the photo opposite), then the sides of the planes themselves become the parallel lines converging at one point on the horizon—or one-point perspective.

Usually, one-point perspective refers to lines or planes parallel to the ground plane. But notice that the top and bottom borders of the railroad car, which is vertical, also appear to converge at the same point on the horizon. Thus, as a plane surface only, without a third dimension, the sides of any plane receding from you will meet at one point on the horizon, when projected that far.

In most cases, the vanishing point of lines parallel to the horizon or eye level occurs on or near the intersection of the line of sight and the horizon, as in the photo opposite above. However, when parallel lines are at an angle to the line of sight, as in the photo opposite below, they will converge at a point elsewhere on the horizon. There may be many such parallel lines (that is, parallel to one another) crisscrossing on the same plane.

If you keep this in mind on following pages, you will understand how *the bases of right solids have different vanishing points, depending on their size and position relative to the horizon and line of sight.*

Just as parallel lines receding into the distance appear to converge, *horizontal lines on planes parallel to the viewer remain level or horizontal.* The size of such parallel planes will change as they are closer to, or further from, the viewer, but their shapes remain the same. Only when a plane is at an angle to the picture plane does it change in appearance.

Horizontal (level) lines on planes parallel to the picture plane remain parallel to the horizon.

TWO-POINT PERSPECTIVE
on a vertical plane

Parallel lines on planes turned away from you converge toward vanishing points on the Line of Sight.

Line of Sight is described on page 109 as the radius of a circle extending from the eyes to the object. Since the head moves around both horizontally and vertically, the convergence of parallel lines occurs on the vertical plane in the same way as on the horizontal plane. The changes in the appearance of given planes are identical in either case. The difference is only in the fact that, on the vertical plane, vanishing points are found on the Line of Sight, on the horizontal plane they are on the horizon.

Take note that in the diagrams on both pages, planes parallel to the viewer remain unchanged in appearance, and that only planes turned away from or at an angle to the viewer change their shape.

In average use, the need for vanishing points on the line of sight occurs but rarely. It is given here to help you understand its most usual use, in three-point perspective and in drawing planes tilted from vertical, explained in detail on later pages.

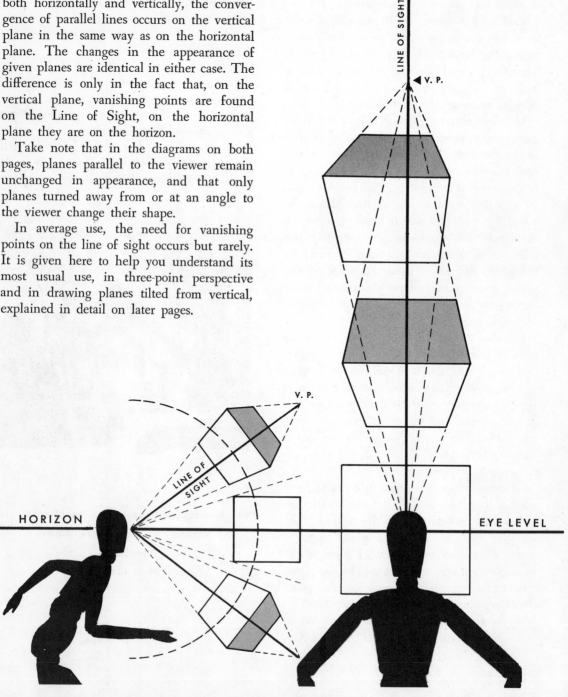

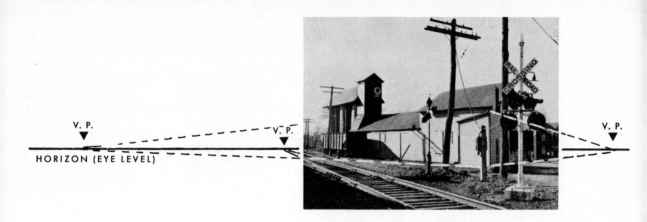

TWO-POINT PERSPECTIVE
on a horizontal plane
Parallel lines on planes turned away from you converge
toward vanishing points on the Horizon or Eye Level.

On the preceding pages you noted that one-point perspective also applied to a vertical plane when it was turned away from you. In that respect it referred only to a single surface whose parallel borders converged toward a vanishing point on the horizon. To represent the depth of an object you must necessarily show at least two surfaces. Therefore when you show a second plane or surface, also turned away from you, its parallel borders will also converge toward a vanishing point on the *opposite side* of the horizon. Now, since there are two vanishing points, one for each plane, you have two-point perspective.

Once you have located the vanishing points for the borders of the planes, *any lines on these planes, which in reality are parallel to the borders, will also converge at the same vanishing points*—as, for instance, the windows on the walls of a house, shown below.

On these pages the objects are in relation to the horizon located within its borders. The next pages show the objects above and below the horizon. As diagrams, the number of vanishing points is kept to a minimum by drawing the objects after the vanishing points have been established. In drawing from life, however, the varying heights of objects will give each its own set of vanishing points, shown below. In addition, objects are not always turned parallel to one another. In this case, also, each will have its own set of vanishing points on the horizon.

When drawing from life the horizon is not always visible. To be sure that your first statement of a subject is correct scientifically, you should indicate eye level on your drawing. To find it, project any two lines that appear to converge, until they intersect. A horizontal line drawn through this point will be eye level or horizon.

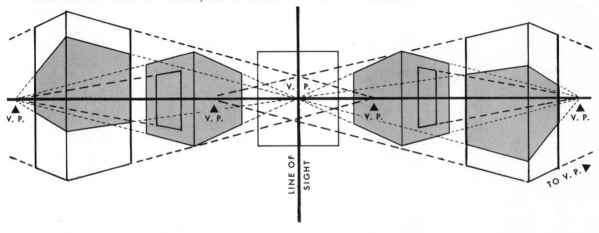

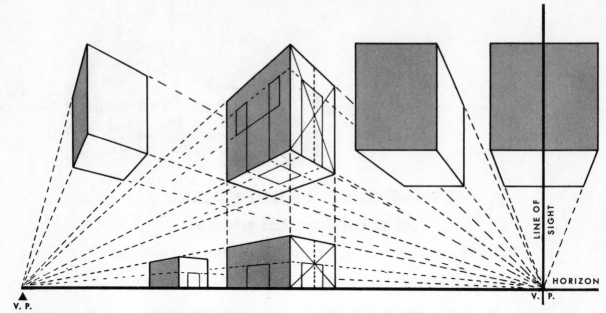

HOW TO FIND THE HORIZON OR EYE LEVEL

So far, two methods have been described for use when drawing from life. The *first,* by definition, shows the horizon as the line where land or water meets the sky or an earth plane rising from the ground plane. Where such a line is hidden from view, *the second method* is to project, on your drawing, any two lines that appear to converge until they intersect. A horizontal line drawn through this point of intersection will be horizon or eye level. *A third method* is illustrated on these pages.

When the sides of upright objects are at an angle to the viewer (or, if you prefer, to the picture plane), their borders appear to converge at vanishing points on the horizon; also lines on these planes which are parallel to the borders. Notice that this is true in all cases *except when these borders are on eye level,* as the base of the object above. In other words, whether as the borders of planes or as lines parallel to these borders, wherever such a line (crossing two planes that are at an angle to one another) appears level or horizontal, such a line will be equivalent to horizon or eye level. This method of locating eye level will be useful to you when working from a photograph where the eye level is related to the station point of the camera, not to where you are sitting.

DIVIDING
A PLANE INTO EQUAL PARTS

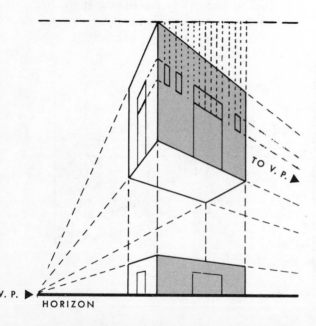

When a plane is at an angle to you, to divide it into a given number of equal parts proceed as follows: draw a horizontal line through the point of intersection of two adjoining planes. On it, measure off the number of parts required, then draw vertical lines through the marks. On the near vertical border of the plane mark the location and height of the shapes you wish to draw. From these marks, draw lines to the vanishing point of the borders of the plane. Where these lines intersect, the verticals will give the shape, in perspective, of each of the parts needed. Use this method to draw windows on a wall, arches in a viaduct, wheels on a locomotive, telegraph poles along a road, etc.

TWO-POINT PERSPECTIVE

upright objects above or below eye level or horizon

When *eye level* is outside the borders of an object, three of its surfaces are visible. In exactly the same way, an object's borders outside the *line of sight* also reveal three surfaces. In both cases, as the object moves further away, above or below eye level, to right or left of the line of sight, its appearance becomes more and more distorted. But notice that, however acute the angle of a plane in relation to the station point (on the line of sight), parallel lines defining its borders meet at the same vanishing point.

In these diagrams, all the objects are drawn to the same vanishing points, for simplicity. Remember that, in drawing from life, objects are turned at different angles to one another, and therefore each will have a different pair of vanishing points. Very small objects show little convergence, and, normally, vertical lines remain vertical at all times. The appearance of convergence occurs only when the object is substantially larger than we are, or are at an acute angle to you. Thus, the degree of angle from the horizontal helps create the illusion of relative size and distance.

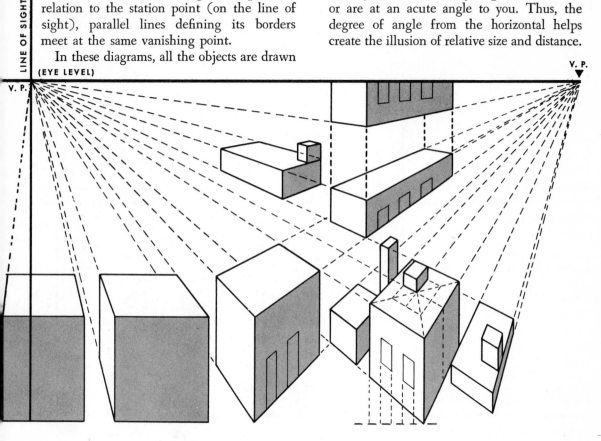

CONSTRUCTING SHAPES ON THE PLANES

The first step always is to find the center of the plane. This is done by drawing diagonals from opposite corners. On a *vertical plane,* a vertical line through the point of intersection of the diagonals will be the optical (not the mathematical) center line of that plane, as seen in perspective. Shapes on this plane may be drawn in relation to this center line as shown on the opposite page.

On the *horizontal plane,* as shown at right above, *the center lines must be drawn in perspective to the vanishing points on the horizon.* To divide this plane into a given number of parts, the marks would be made on a *vertical* line and then connected to the vanishing points. This floor plan is a base on which shapes can be constructed, in relation to the borders of the plane containing it.

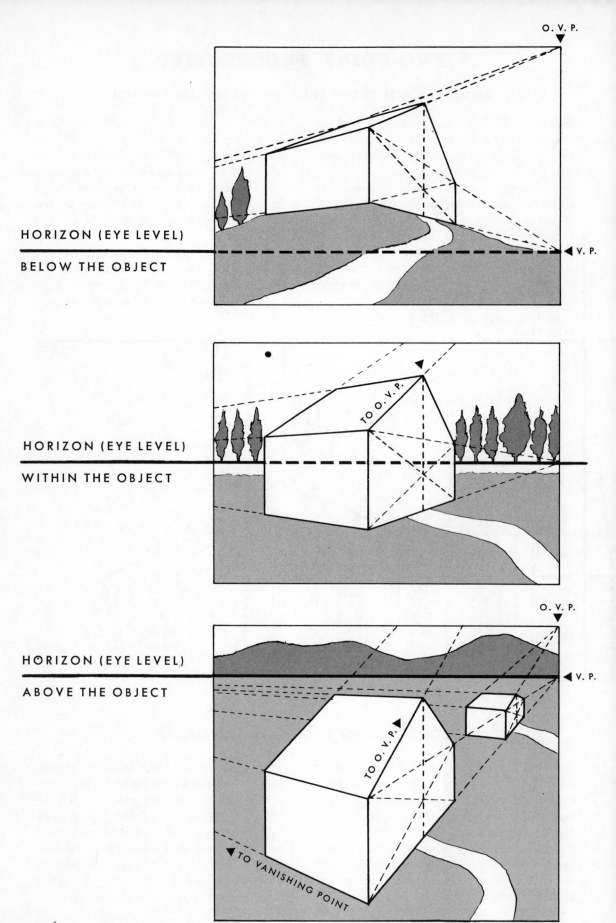

O. V. P. ▼

HORIZON (EYE LEVEL)

BELOW THE OBJECT

◄ V. P.

HORIZON (EYE LEVEL)

WITHIN THE OBJECT

TO O. V. P.

O. V. P. ▼

HORIZON (EYE LEVEL)

ABOVE THE OBJECT

◄ V. P.

TO O. V. P. ▼

◄ TO VANISHING POINT

FINDING THE VANISHING POINT

FOR THE OBLIQUE (or slanted) PLANE

**Parallel lines
on planes slanted from the horizontal
converge at points above
or below the horizon.**

O. V. P.

O. V. P.

O. V. P.

V. P.

V. P.

① ② ③ ④ ⑤ ⑥ ⑦ ⑧ ⑨

As an example of a slanted plane the illustration shows the peaked roof of a house or barn. Other familiar slanted planes are the open pages of a book, a ramp in a stadium, an artist's easel. In all cases, the vanishing point of such a plane is always found somewhere on a vertical line drawn through the vanishing point on the horizon of a side, or vertical, plane. In relation to the oblique or slanted plane, then, this point is called the *Oblique Vanishing Point,* or *O.V.P.*

Just as with upright or level planes, there may be several slanted planes in a subject, each at a different angle to the horizon. Therefore each plane would have it own vanishing point on the Oblique (Vertical) Vanishing Line.

TO FIND THE OBLIQUE V.P.
OF A GIVEN PLANE:

1. Locate the vanishing point of a side plane on the horizon if outdoors, eye level if indoors.

2. Draw a vertical line through this point to make the Oblique Vanishing Line.

3. Locate the center of the side plane by means of diagonals and draw a vertical line through it.

4. On it mark off the height of the Oblique plane relative to borders of the side plane.

5. Connect the height mark on the near top corner of the side plane with point 4.

6. Extend this line until it meets the Oblique Vanishing Line (step two).

7. The Oblique Vanishing Point (O.V.P.) is at the intersection of these two lines, and all parallel lines on this slanted plane will converge to this point.

8. Connect the far top corner of the other side plane with the Oblique V.P.

9. To enclose the slanted plane, connect point 4, the height mark, with the eye-level vanishing point for the other side of the object.

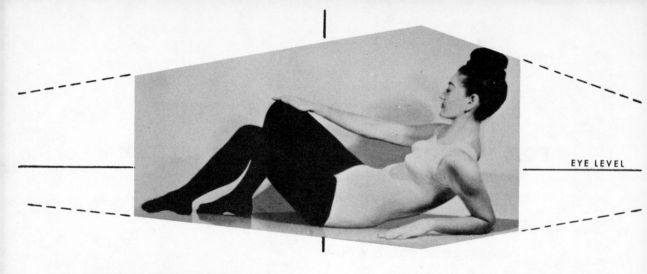

EYE LEVEL

FORESHORTENING

The word means: to represent, in drawing or painting, objects as they appear when seen at an angle, or obliquely—which is the same as saying to draw them in perspective. In practice, the word usually describes the appearance of objects that are distorted more than average because the parts nearest the station point are exaggerated in size in relation to the remainder of the subject.

This distortion takes place, as shown in the photographs, in direct ratio to the degree of angle made by the meeting of the forward edges of the two side planes imagined to contain the subject. Your eyes are like the lens of a camera and reproduce images in the same way. Everyone is familiar with the odd effects produced in photography when one part of the subject, such as a hand or foot, is very close to the lens, compared to the rest of the figure. Thus, the closer your station point is to the subject, when it is at an angle to you, the more distortion takes place.

Average subjects with a foreshortened effect will not require more than two-point perspective in relation to eye level or the horizon. However, when the subject is tilted from vertical, or extends much below or above the horizon, then three-point perspective will develop. The latter is described on the next page, and would apply, for instance, to drawing the appearance of a statue located above eye level—or looking down at a figure seated on a staircase.

Depending on your purpose, you must either compensate for, or heighten, a foreshortened effect. If your station point is such that the subject appears more distorted than you wish to represent, then you should reduce the angle of perspective in making your drawing. Sometimes, for dramatic effect, you may wish to emphasize the forward portion of a subject in relation to the whole. In this case, increase the angle made by the forward edges of the planes containing the subject.

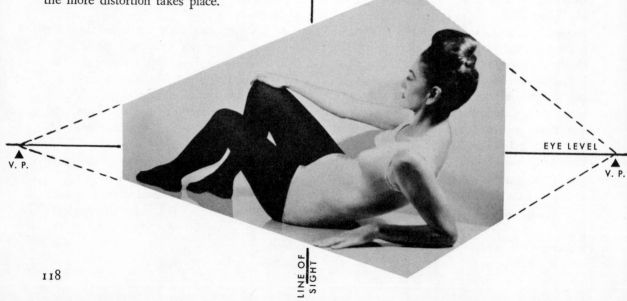

V. P.

EYE LEVEL

V. P.

LINE OF SIGHT

THREE-POINT PERSPECTIVE

The need for a third vanishing point to accurately describe an object arises mainly in two cases: when the vertical sides of an object extend much beyond eye level, as in viewing a skyscraper or looking down a staircase, and also when the upright sides of planes are not truly vertical but tilted. *Always, in both cases, the lines when related to the horizon will have their vanishing points upon it.* Only the lines related to the vertical, or line of sight, will recede to the third vanishing point.

In the case of a tall building, this third vanishing point, for the vertical sides of its planes, is far beyond the borders of the drawing because it is located somewhere in the sky. In this instance, the third vanishing point is called a *Vanishing Trace* or *V.T.*, and all

the vertical sides will appear to converge toward it on the Vanishing Line, which is now the Line of Sight.

When an object is tilted from an upright position its sides also appear to converge on the Line of Sight, on a line parallel to it, thereby establishing Vanishing Point Three. Vanishing points one and two are on the horizon, hence the term three-point perspective. As you see in the diagram at right, the top plane of a tilted object is now a slanted plane, so that its vanishing point is on the *Oblique Vanishing Line,* drawn vertically through the vanishing point of the base on the horizon.

TO VANISHING TRACE ▲

TO V.P. 3 ▲ V.T. ▲

O. V. P.

TO VANISHING POINT ◄

V. P. ▼

HORIZON

EYE LEVEL

LINE OF SIGHT

VANISHING POINT

V. P. ▼

TO OBLIQUE

VANISHING

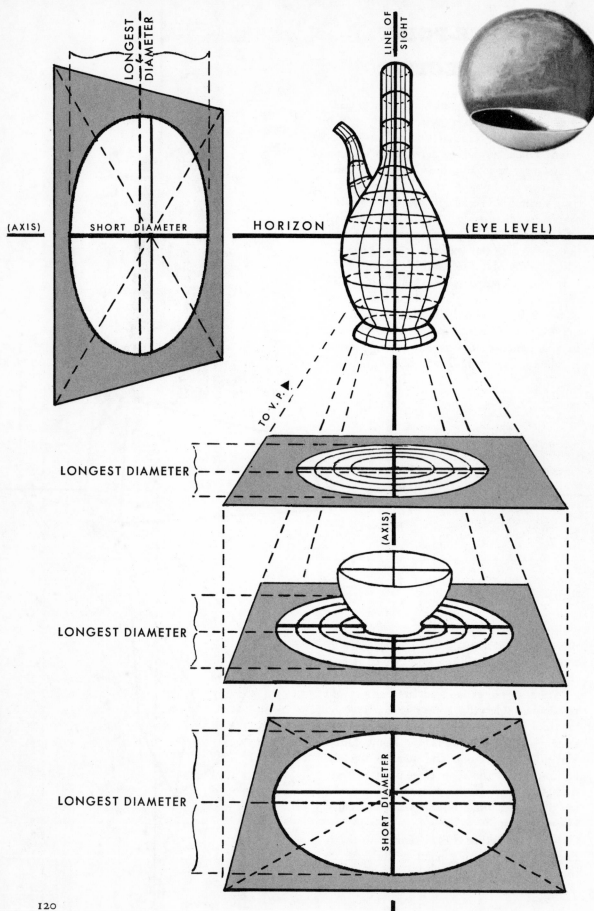

LONGEST DIAMETER

SHORT DIAMETER

(AXIS)

LINE OF SIGHT

HORIZON (EYE LEVEL)

TO V. P.

LONGEST DIAMETER

(AXIS)

LONGEST DIAMETER

LONGEST DIAMETER

SHORT DIAMETER

THE CIRCLE IN PERSPECTIVE
appears as an ellipse.

As the circumference of a sphere or round body, the circle is a curved line every part of which is equally distant from a point within it called the center. It follows then, that all straight lines drawn through the center to the circumference are equal. Any such lines are called diameters. In drawing circles in perspective, however, only two diameters are generally used, *at right angles to each other.* If you think of a sphere as layers of circles, whether upright or level (like the lines of longitude and latitude on the globe), you will see why a rounded object such as a bowl (which is a portion of a sphere) is composed of layers of circles all related to the same diameters.

When a circle is on the vertical or picture plane, it appears perfectly round. However, when seen at an angle to the line of sight when upright, or at an angle to the horizon when level, the circle is receding from you in relation to the plane on which it is described. When seen thus, the circle no longer appears round, but rather as a flatter shape called an ellipse. This is because one of the diameters is receding and is therefore shorter than the other. The ellipse, then, has a *long* and a *short* diameter, not diameters of equal length as in the circle.

DRAWING THE ELLIPSE: A true ellipse is uniform in shape, or symmetrical, in each of its quarter sections, and rounded at the ends. No matter how flat it is, the ends are never pointed like a football. How round or flat its shape varies with the length of the short diameter in relation to the long diameter. To get the feel of the correct shape for an ellipse, mark off equal lengths from a point on a horizontal line. On a vertical line through this point, mark off equal though shorter lengths from the point of intersection, which is now the center of the ellipse. Draw an oval through the four points at the ends of the long and short diameters. To find how symmetrical your ellipse is, draw on tracing paper. By folding the paper along the diameters you can compare each quarter section with its opposites. With a little practice you will soon be able to draw symmetrical ellipses.

THE SIZE OF THE ELLIPSE: The size varies in relation to the position of the ellipse on the horizontal or vertical plane. Since a circle represents a portion of a sphere described on a flat plane, its shape changes as the plane turns away from a position parallel to either the horizon or the line of sight. The more of the plane you see, the rounder the ellipse. The less you see, the flatter the ellipse, until at eye level or the line of sight, it appears only as a straight line, shown in the bottle opposite.

THE CIRCLE IN ONE-POINT (parallel) PER-SPECTIVE: When the circle is on a plane parallel to the horizon, the *longest diameter* is always parallel to the horizon and is always drawn as a horizontal line, as, for example, in drawing a bowl on a table, or a silo outdoors. On a vertical plane, the *longest diameter* is always vertical, and therefore at right angles to the horizon or eye level. This rule must always be observed.

THE LONGEST DIAMETER: *This is always drawn through the mathematical center of the ellipse,* whether vertical or horizontal. Unlike a photograph, your drawing of an ellipse must be symmetrical, and therefore requires a single center for both the long and the short diameters. In a photograph we accept the distortion of perspective, which makes the near half of an ellipse appear larger than the far half. This distortion increases as the ellipse gets rounder. When seen as part of a cylinder, or reproduced in a photograph, the center line, say of a target, will pass through the perspective center of a plane, located by diagonals, and is therefore shorter than the *true* or *longest diameter.*

THE SHORT DIAMETER: This is also known as the axis of the ellipse. The reason, illustrated opposite, is the definition of the word axis as representing a line connecting the center points of a geometric body, and contained within it. As an imaginary line, then, it connects the centers of circles one over the other. On horizontal planes the axis is always vertical. On vertical planes it is level only when located on the horizon or eye level.

THE SHORT DIAMETER (Axis)

of a circle on a receding vertical plane
is in perspective to the Vanishing Point on the Horizon.
The Long Diameter is always drawn
at right angles to it.

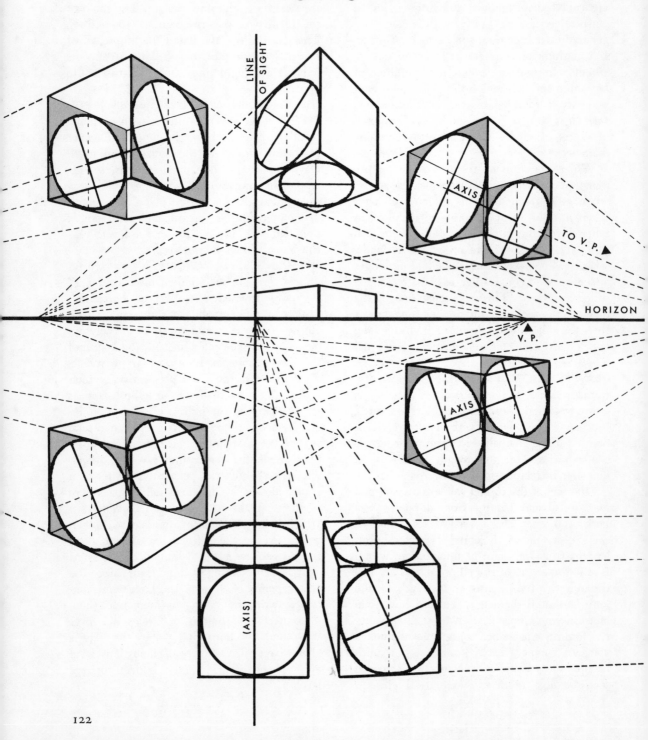

THE CIRCLE
seen at an angle

On the preceding pages the circle is explained when viewed in simple or parallel perspective. When located on planes parallel to the horizon or eye level, the diameters of such circles are always horizontal or vertical—illustrated again (opposite page) on the top and bottom planes of the boxes. On vertical planes receding from you, however, the circle is in perspective; that is to say, its short diameter is related to the vanishing point on the horizon or eye level. Only when coinciding with the horizon will the short diameter appear level. As it is raised or lowered above or below eye level its angle becomes more acute relative to the horizon. Because you need two diameters at right angles to one another in order to draw a symmetrical ellipse, first find the short diameter in perspective to the vanishing point on eye level. The long diameter is then drawn at a right angle to it through its *mathematical* center.

Circles at an angle to you appear on such familiar subjects as clocks, arches on bridges, wheels. You will find them easier to draw if you think of them as the ends of cylinders, as shown in the diagrams opposite. In this way you can see how the short diameter is synonymous with the axis of the cylinder, and as such is inside of it, receding to the horizon.

THE LONGEST DIAMETER: As described in parallel perspective, this is located in the mathematical center, not the visual center, of the ellipse. On a vertical plane, it is a vertical line equidistant from the vertical sides containing the ellipse. Since your *long* diameter is in perspective, it appears, and actually is, shorter than the *true* or *longest diameter*. Therefore, to show its true length, measure the length of the *longest* diameter (on a vertical line) and mark off this length on the long diameter of the ellipse.

DRAWING AN ELLIPSE ON A RECEDING VERTICAL PLANE

(EYE LEVEL)

V. P.

1. Find the *perspective center* of the plane by means of diagonals from opposite corners.

2. Draw a horizontal line through this center. A point midway between the sides is *true center*.

3. Draw a vertical line through the true center point. Its length between top and bottom of the plane is the length of the *longest diameter*.

4. Connect the true center with the vanishing point on eye level, then extend it. This line is the *short diameter* or *axis* of the ellipse.

5. Mark off the length of the short diameter, equivalent to the length of line in step 2.

6. Draw the *long diameter* at right angles to the short diameter. Its length is the same as the *longest diameter*—step 3.

7. Using the two diameters, draw a symmetrical ellipse within a rectangle (dotted lines).

THE CYLINDER
seen parallel to you

The axis of a cylinder does not join its sides, but is between them. It is the Short Diameter line because it connects the centers of the circles on the ends.

Just as a box may be imagined as layers of flat planes, so a cylinder is made of layers of circles. When the circles are on planes parallel to the picture plane they are in simple perspective, as shown on page 120. Normally the cylinders you draw are upright, so that the axis is a vertical line. Occasionally, however, the cylinder may be tilted from a horizontal or vertical position. As long as it remains parallel to the picture plane its construction remains the same as when upright, shown in the illustration at left. To draw a tilted cylinder, first indicate the axis line in relation to the horizon or eye level. On it mark off the length of the cylinder. Draw the ellipses at the ends as they appear to you, but keep in mind that ellipses appear rounder as they turn further from the line of sight or horizon. Through the center point of your ellipses draw the long diameters at right angles to the axis, or short diameter line. On them mark the width of the cylinder. Join the marks with straight lines, for the sides.

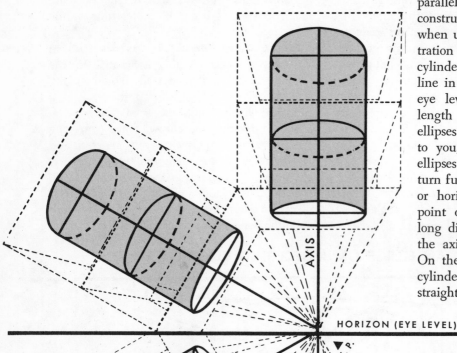

AXIS

HORIZON (EYE LEVEL)

▼ V.P.

THE CONE

Because the cone has a circle for its base it is related to the cylinder. Unlike the cylinder, whose circles are identical, the cone is made of circles whose progressively shorter diameters disappear at a point called the apex. Because most cone shapes you draw are not complete cones you will find it helpful to first draw the cylinder, and then construct the cone within it. Draw the ellipse at the base, as in a cylinder, then connect the ends of its long diameter to the apex of the cone located on the axis line *to make the sides.*

THE CYLINDER
seen receding from you

When a cylinder is on a plane receding from you the circles at its ends are in two-point perspective because the axis or short diameter line is no longer horizontal or vertical, but slanted toward a vanishing point on the horizon. To construct them, then, follow the same procedure shown on the preceding pages. Because the sides of a cylinder are straight lines, the axis line is midway between them, meeting their vanishing point.

Shown at right is the relation of the cylinder to a rectangular body. Because it is round, only the longest diameter touches the planes of the box. The actual sides of the cylinder as you see them, however, are much further inside the box, and are drawn to connect the ends of the long diameters of the ellipses, *never the ends of the vertical or longest diameter,* which is used only to help draw the ellipse.

The sides of a cylinder always connect the ends of the long diameters.

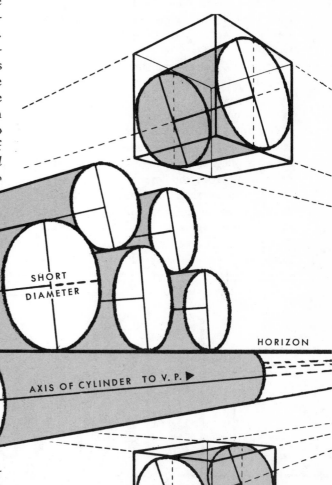

TO VANISHING POINT

SHORT DIAMETER

HORIZON

AXIS OF CYLINDER TO V. P. ▶

In the illustrations above notice the different angles to the vertical of the long diameters of the cylinders. This is because they are always drawn at right angles to the axis or short diameter line. Just as the sides of the cylinder are at different angles to the horizon, so, too, does the midline between them, or axis, change its angle relative to horizontal. Therefore, to construct cylindrical shapes such as rolls of paper, wheels on a vehicle, arches in a viaduct, *find the axes first, then draw the long diameters of the ellipses at right angles to them.*

The long diameters of a cylinder are always at right angles to its axis.

PLANES IN A CYLINDER

A common problem in drawing is the proper representation of several planes on a single axis, each at a different angle to you. Examples are open books or portfolios, open doors, revolving doors, vanes in a ventilator. Easiest to understand is a revolving door, but the other examples follow the same principles. In the door, each section rotates on a central axis, and therefore moves in circles forming cylinder ends. By first drawing the complete cylinder in perspective to the horizon or eye level, you can locate any planes within it.

Start by placing the long sides of the planes where you want them in the cylinder, to reach its ends. *The short sides of each plane,* which are in perspective—that is, receding from you—*will converge at the same vanishing point for that plane.* These points, for each plane, are on the horizon for vertical planes, or on the line of sight for horizontal planes. When the planes are *slanted,* as in the case of the pages of an open book, the vanishing points are on the *oblique* vanishing lines. As described on page 117, such lines are drawn vertically through the vanishing points on the horizon.

Planes attached to a single axis revolve in circles.

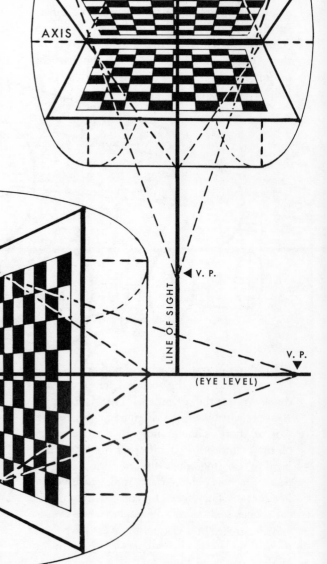

REFLECTIONS

Reflected points on water are always directly under the real points.

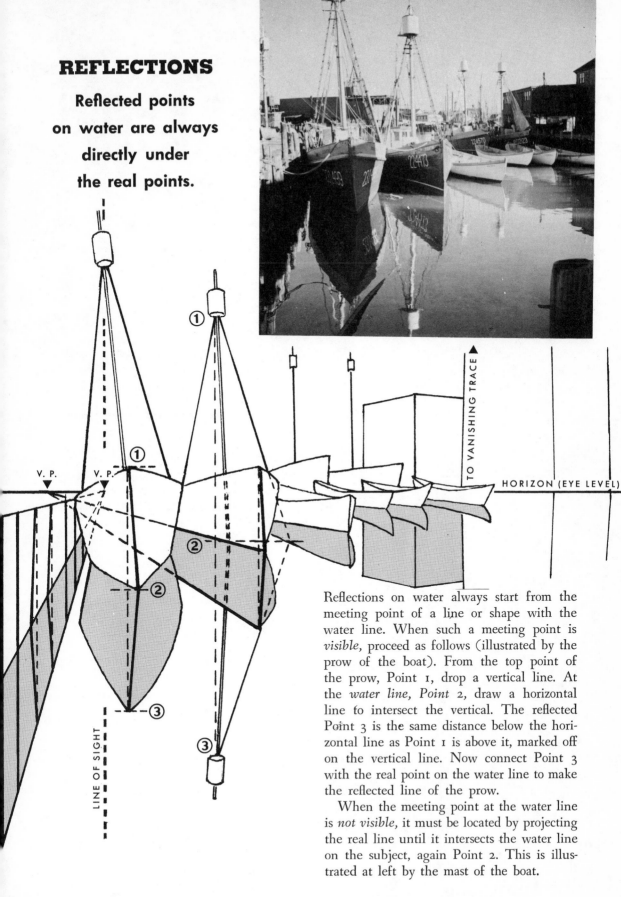

Reflections on water always start from the meeting point of a line or shape with the water line. When such a meeting point is *visible*, proceed as follows (illustrated by the prow of the boat). From the top point of the prow, Point 1, drop a vertical line. At the *water line*, *Point 2*, draw a horizontal line to intersect the vertical. The reflected Point 3 is the same distance below the horizontal line as Point 1 is above it, marked off on the vertical line. Now connect Point 3 with the real point on the water line to make the reflected line of the prow.

When the meeting point at the water line is *not visible*, it must be located by projecting the real line until it intersects the water line on the subject, again Point 2. This is illustrated at left by the mast of the boat.